Cover
Peter Mendelsund

Photography
George Baier IV

Book Design
Pablo Delcan
Peter Mendelsund

Production
Randy Reed

 powerHouse Books

Brooklyn, NY

er

Cover

Text © 2014 Peter Mendelsund
Photographs © 2014 George Baier IV
Introduction © 2014 Tom McCarthy

All other texts © their respective owners and used with permission.

All published cover images reprinted with permission.

Published in the United States by powerHouse Books, a division of powerHouse Cultural Entertainment, Inc.
37 Main Street, Brooklyn, NY 11201-1021
telephone 212.604.9074, fax 212.366.5247
e-mail: info@powerHouseBooks.com
website: www.powerHouseBooks.com

First edition, 2014

Library of Congress Control Number: 2014936793

ISBN 978-1-57687-667-1

Printed by Toppan Leefung Printing Ltd

Design by Pablo Delcan and Peter Mendelsund

10 9 8 7 6 5 4 3 2

Printed and bound in China

For Karla

Table of Contents

Introduction by Tom McCarthy	XII
Foreword by Peter Mendelsund	XIV
Classics	1
Choosing Colors	24
Jane Mendelsohn	32
Covering *Lolita*	54
Reading in the Digital Age, or: Aphorisms for a Future Book	60
Vertical	65
Literary Fiction	89
Ben Marcus	90
Alexander Maksik	104
What Is a Book Cover?	110
Mark Z. Danielewski	119
"How did you get *that* approved?"	130
Steven Amsterdam	132
Charles Yu	143
Genre Fiction	144
Jo Nesbø	149
"Making 'Tattoo' Indelible"	162
Nonfiction & Poetry	173
James Gleick	177
Jed Perl	201
Nicholas Fox Weber	210
Process	223
Anatomy of a Cover	237
Q & A	257
Next	261
Acknowledgements	270

A cover designer, first and foremost, is a reader.

He or she may not be the *first* reader (that role falls, officially, to the editor and, unofficially, to the writer's partner); better to say, the most radical. His or hers is a fundamental act of reading, in an almost literal sense: a reading that looks through a book's carapace to pinpoint its foundations—that discerns, like Eliot's Webster, the skull beneath the skin. Cover designers read books in the way that soothsayers read leaves or entrails; in the way cryptographers read documents that to the layperson may look quite innocent. To phrase it in more formal philosophical terms: they are Phenomenologists, engaged in lyrical and penetrative acts of drawing-out, of making-manifest.

What are they making manifest, though? Only bad books have a "message"; we have (thankfully) jettisoned our belief in authorial intent, alongside any notion that a text might have an underlying, base "meaning." And yet *something* is being drawn out and made manifest by a good cover designer. This something, I'd suggest, is neither truth-kernel nor any other kind of *deus-ex-machina;* rather, it is the matrix, the grid, the schemata of the book's very legibility—if you like, a codex that allows reading itself to begin. Far from being a codex that "explains" the book, reduces it or fixes it semantically, it is one that sets off the whole, complex set of mechanisms through which meaning is produced—or, rather, mea*nings*: escalating, contradictory, vertiginous—that sets off, in other words, the grand adventure that lies at the heart of literary experience.

Watching a good designer at work (and, seeing Peter Mendelsund in action, I've been privileged to observe perhaps the best one of his generation) is fascinating. They read not just in fundamental ways but in ones that I can only describe as eccentric. They read against the grain, counter-intuitively: the last thing they want is to be distracted by the road-signs that supposedly instruct you how to read a book, but actually (like that road-closed barrier beside the bush in the

old *Batman* TV series, that diverted other drivers from the bat-cave's entrance) cover up the lines of association, short-cuts, and relays around which the text is really structured. My British cover designer reads her novels backwards, so as to free their images from the camouflage of plot. This is a good idea. Mendelsund reads backwards, forwards, and askew—most of all, *across* and *through*. He is extraordinarily well-read; in an increasingly illiterate culture— and (it must, sadly, be stated) an increasingly illiterate publishing industry— he's immediately able to hear echoes and cadences of all the other texts burrowing and worming their way through the body of the one in front of him. It seems no coincidence that he's also a virtuoso pianist: he has a fine-tuned ear that picks up the cross–frequencies, detects the melody within the noise— or, rather, the cacophony within the melody. He knows his Shakespeare, Ovid, Joyce, and Kafka; also his Freud, his Lacan, Marx, and Foucault and so on. To put it really simply: he *gets* it—gets what writing is about, and what's at play, or stake, within it.

But then it's not just a case of getting it; nor is it one of mapping, indexing, or "illustrating" a series of references or coordinates. When Mendelsund is sound- ing a book's Unconscious for his cover image, something else comes into play. The only way that I can begin to understand this something-else is through recourse, once more, to the mystic, to those tea-leaf entrails. Mendelsund's covers don't show you what's *there,* even a hidden what's-there; they show you what *isn't* there—and conspicuously so: the kind of not-there that, as soon as it's shown to you, you instantly recognize, darkly familiar as a murder weapon. Thus Kafka's *Metamorphosis* is rendered not by insects but by eyes; and from Joyce's *Ulysses,* from the very letters of its title, is extracted (then set back in place again) the climactic word that is the book's (and literature's) own affir- mation—the loudest word of all precisely because it *isn't* spoken: *Yes.*

Chopin's Funeral and the Future of Life

Eleven years of work. That's what this book represents—eleven years of my working as a book cover designer. It seems absurd that I've been at it for so long now—when I first entered this peculiar profession I didn't think I'd last a month, let alone this decade-and-change. On the other hand, eleven years as a book designer seems a mere blink when considered against the thirty-some-odd years I'd spent practicing another discipline entirely. That is, before I stumbled into a career making book jackets, I used to play the piano every day—I used to be a classical pianist.

During those years at the piano, I was completely unaware that book cover design, as they say, "was a thing." Though I'd read plenty of books over this period, it had not really occurred to me that a book's cover was consciously composed and assembled by a human agent. Not that I assumed book jackets were made by machines, or committees (it turns out they can be made by either), I simply had never given book jackets a passing thought.

What did I see then when looking at the front of a book if not the cover? The title and the author's name. Which is to say, I saw past the cover to the book.

Of course it is now nearly impossible for me to willingly conjure what this naive state felt like, so immersed am I in all things design-related. Yet the fact remains—there are people in this world who are utterly blind to book covers, people who ignore them totally, who never think about the strange parameters and contingencies that bear upon their creation—and I was one of these people.[1] I can remember the exact moment it dawned on me that book jackets needed to be *designed,* and it was about three or four months before I was hired at Knopf to perform this exact function. I had been investigating graphic

1 And I am further tempted to say that perhaps this group (those oblivious to book jackets) might comprise a majority of our species—and God bless this demographic. After all, aren't the title of the book and the author's name the only truly important things a reader should know about a book prior to reading it? When you get right down to brass tacks, do we really even need book jackets, beyond their previously stated role as bearer of these two salient facts?

design as an alternate career to music (more on this in a moment) and by some great chance an interview had been set up for me at Knopf with a designer there (Chip Kidd). Not wanting to go into the meeting blind, and encouraged by the designers I already knew, I ventured out to the local independent bookstore in order to investigate these newfangled "jackets" everyone was on about, and lit upon two appealing examples instantly. The first was Carol Carson's gorgeous jacket for Anne Carson's *Autobiography of Red,* a paragon of restraint and elegance; and the second was Gabriele Wilson's jacket for the novel *Balzac and the Little Chinese Seamstress.* "Why," I thought, "these jackets are beautiful—they stand out amongst their more prosaic neighbors, evoke a special atmosphere, communicate something particular about the author's work, and awaken in me the desire to own these books and investigate them further."

As I mentioned, I used to play the piano.

Since I was a boy I have spent a hefty chunk of my life at the instrument, and I always assumed the cumulative effect of all this practice was that I would become a pianist. And I did become a pianist, briefly, if the standard for being a pianist is performing concerts that other people attend, performing these concerts with a reasonable degree of proficiency, and performing them on the piano. Unfortunately, another, perhaps truer standard for being a pianist is making a decent livelihood performing, and thus it eventually, painfully, occurred to me that I wasn't really making the grade. There were certainly obstacles along my path in music which may have tipped me off earlier to the fact that I wouldn't become, say, Glenn Gould (my once-and-always hero). Not having a photographic memory was always a massive handicap. Classical piano concerts have been, since Franz Liszt invented the conventions comprising the solo recital, performed without a score—and the repertoire for the instrument is huge and varied. Though memory is the least remarked upon of pianistic virtues, almost every famous classical pianist has a perfect, or near perfect one. Being prone to depression didn't help either. Pianists spend the majority of their days indoors, alone with their thoughts, and people like me whose thoughts tend to bore, accusatorily, inwards, shouldn't be too long without the company of their fellow man. Finally: despite the intensity of my desire to perform, I didn't quite have the same degree of near psychotic monomania that my fellow classical pianists seemed to possess. From a professional perspective, I got by—I have the technique to play the more difficult works in the repertoire, and a very good sense of what a particular score means to communicate. But I occasionally lose the requisite *sang froid* needed to bring the

composer's thoughts to a faultless fruition. In other words, what I lack as a musician is consistency and poise. All of which is to say that I should have seen the end of my musical career coming earlier.

The year after I finished grad school at conservatory, my first daughter was born, and by the time she was one, my master plan had begun to fall apart. I was playing concerts in Manhattan and trying to make the odd buck as an accompanist and as an adjunct teacher (composition, orchestration, theory) and the baby, my wife, and I were failing to peacefully coexist in a cramped New York apartment. When she was asleep, I couldn't practice or I'd wake her. When she was awake, she would require a jaw-dropping level of attention and supervision (which, of course, I loved supplying her with). But the music was suffering. I couldn't keep up the level of play I needed to survive in the field. (Furthermore, we had no health insurance.) I had just auditioned for one of the country's major music festivals, and come up third place (otherwise known as the alternate, which means I didn't get to go) and that particular setback, coupled with other smaller ones, compelled me to start wondering about the track I had been so stubbornly committed to. The questions continued to mount, and led fairly rapidly to a crisis. What followed: an ever-building depression (to which, as I mentioned, I've always been prone) that, surprisingly, felt more like a state of immobility and gray homogeneity than one of melancholia or grief: an interminable, inertial joylessness. I tried to keep playing through it, but couldn't. Though I always mention my family's financial exigencies when asked why I left music to become a designer, it was ultimately a depression— its unrelenting fug—more than any financial concerns that led to the decision to finally call time on my sputtering musical career. People seem to enjoy hearing the cheerier and more condensed version of my story—the Kaspar-Hauser-style mythic version—which runs something like: *I was a pianist; then I taught myself design from scratch over a ridiculously short period of time; then Chip Kidd hired me at Knopf.*

Huzzah!

I get asked about this process a lot, the segue from music to design and the more I tell the italicized story above, the more it begins to feel like the fable it truly is.

Thirty years is a long stretch in which to think of oneself inextricably bound to a particular activity or profession, only to be obliged, all at once, to adopt a new

self-definition. I assumed that my first job after leaving the piano would be a temp job—and, now that I'm looking back, I recall imagining at the time that I would probably end up as an office temp for the *rest of my life.* I was fairly certain I had no non-musical skills to speak of and was all but useless to the larger world. I didn't even believe I'd make a good temp (I probably wouldn't) and so was resigned to a life of utter worthlessness.[2] Buoying me was the thought that maybe this whole career shift might be only a provisional one, and that eventually I'd find my way back to Beethoven, Bach, and the gang—but only after accruing enough cash and acquiring a skill set (so strangely denied me) which allowed seemingly everyone else in the world to get through their days effortlessly and with a minimum of inner torment. The working world would teach me these skills. No more crying in the shower. But first I needed a job.

Thus it was that my wife and I sat down on the floor of our living room and began to brainstorm about, as she put it, "things Peter Mendelsund likes to do other than make music."

Me: "I like *soccer*?"

Wife: "Yes, but as far as I know you can't really make money playing in pick-up soccer games."

Me: "How about books—I enjoy reading books…"

Wife: "Do you want to *write* one maybe?"

Me: "Um—no."

Wife: "That's good, because, writing, well, you know, with all the solitude and low pay, it would be kind of like back to square one wouldn't it?"

Me: "True. Hmmn, well, I've always liked to draw…can I draw for a living?"

Wife: "You mean, like a cartoonist?"

Me: "Well, no, I'm not really funny…"

2 Again, I'm not sure that being a working (and dare I say it, um, reasonably "successful") book designer qualifies me for citizen of the year. Book jackets don't really contribute to the common weal, do they? But neither are book jackets the *worst* thing in the world. They are both culturally and aesthetically preferable to, say, PowerPoint presentations or Excel spreadsheets.

Wife: "Draw? Like…like one of those portrait guys in Central Park?"

Me: "No—jeez, I mean more *generally speaking*—are there any jobs that are visual, like, I don't know, maybe I could be a house painter?"

Wife: "A *what*?"

Me: "You're right, maybe I should just wait tables…"

Wife: "I've waited tables and, with all due respect, I'm not sure you are cut out for that line of work…"

Me: "Maybe something secretarial?"

Wife: (eyes closed, hands rubbing temples) "What about *design*?"

I had designed our wedding invitation. It wasn't anything special, but I had taught myself the software QuarkXPress in order to do so, and I had found the process engaging. Also (and perhaps more crucially) I had several pieces of graphic design made *for me* over my years at the piano—CD covers for my own music, posters for concerts, programs, and such—and had the distinct feeling on these occasions that the designers at the controls could use my help; that despite the fact that I didn't know how to design anything myself, I knew clearly and without doubt what it was I liked and didn't like. I've said in the intervening years that nothing galvanized my desire to design, and solidified the knowledge that I *could* design, more than this feeling—the sense of know-ing in my bones what was good design work, and what wasn't.[3]

So how hard could design be for me to learn?

Nowhere near as difficult as classical music it turns out. Once I began experi-menting with design—which I began doing in earnest almost immediately after my wife first said the word "design" on the floor of our living room—I found the enterprise so much simpler than my previous, musical one. The learning curve was less steep (by several orders of magnitude). Allow me to perform a little compare-and–contrast:

3 Being critical has always been, for me, the handmaiden to being creative. It is famously easy to become enamored of one's own bad ideas, and just as easy to fetishize one's process—but in the end it is our ability to adequately judge our own work (with as close to an unbiased eye as possible) which determines the quality of what we make.

1. When composing or performing a sonata, or a dance, or a film (or a sentence) one must hold in one's mind the entirety of the work in question, in order to know if that particular idea, note, step, or phrase can be successfully integrated. When I am playing music, or writing it, the deeper I delve into a particular piece, the more I have to play through that work, or imagine it, in order to contextualize my changes or additions to it. With a single piece of graphic design, you can tell *at a glance* if something works or not!

2. With design, there seems to be no real technical barriers to entry—i.e. designers don't need to study from a ridiculously young age, competing against crypto-autistic, graphic design prodigies with eidetic memories, tiger moms, and the entire cultural weight of an (often underdeveloped) nation bearing down upon them.[4] Designers don't need a ton of "technique"—there is in fact no dexterity or physical coordination involved. Playing a decent double trill is exponentially more difficult than learning how to make a Bézier curve. And not, like, just for me. It simply *is*.

3. From a creative standpoint, a designer rarely needs to confront "the blank page" as a composer will. Designers always have a reasonably specific task to accomplish, and their work will be judged, ideally, on its ability to accomplish that task.

4. With design there is none of this namby-pamby "profundity" I was previously contending with. *Clever* and *pretty* seem to be the benchmarks of good design. *Smart* is encouraged, but not necessarily de rigueur. (The title of this book, *Cover,* is intentionally ambiguous, but one of its possible meanings concerns outer layers and surfaces. Design, at least most design, seems to dwell in and upon just such exterior, surface concerns.)

5. Design jobs are not exactly a dime a dozen, but there are more available to the acolyte than the, oh, *twenty* or so good jobs that exist for classical pianists worldwide. If you are arrogant enough to actually want to perform at the *top* of your field, well, you have a better chance winning the Nobel Peace Prize than of becoming a *famous* pianist. The field of design, on the other hand, seems entirely populated by "famous designers." I meet a new one almost every month.

6. Design is not performed. It is, rather, *endlessly rehearsed.* Designing is like

4 Music conservatories are seriously messed-up places.

practicing: one iterates; makes amendments; tries new avenues... Practicing is a snap, as one is allowed, expected even, to make mistakes. Practicing is a judgment-free zone. Mistakes are not allowed in concert halls.

7. On a more subjective note, design carries no psycho-emotional baggage for me, my family, or for the Mitteleuropean Jewish culture from which my family and I spring. Other Mendelsunds (of this or any past generation) would most likely consider design a *lightweight* pursuit—the kind one enjoys, but doesn't really work at, like croquet, or whistling. If designing were, say, the only acceptable way out of the shtetl (like music and science once were), or if my father or mother had been designers and thereby had bequeathed to me even a modicum of the anxiety of influence, I probably would have found myself having less fun at my current job, and as a result would have made much poorer work.

In any case, "Design is easy," (and book jackets are trivial and unnecessary) is, as you may have noticed, a bit of a mantra for me. This is because it is, to some extent *true,* but also because it is a useful thing for me to believe. Believing in the simplicity of design helps me maintain a design practice that isn't overly neurotic, or needlessly complex.

Believing makes it thus. I was never able to support this frame of mind at the piano. Make of that what you will.

So, as I mentioned in *Peter Mendelsund Becomes a Designer—The Abridged & Sanitized Edition,* there was a short period during which I "taught myself design."

And this too is a slyly deceptive statement.

The period in question may have been eight months, it may have been ten, I don't really remember—it was certainly less than a year—but more importantly, I never "taught myself design." What I taught myself was *just enough* design to get a design job. Meaning: very little design. I am still learning design now, and not in some nebulous, poetic sense. I am, every day, discovering details about the discipline that most design students twenty years my junior already know inside and out. I'm referring to humiliatingly obvious stuff. I am regu-larly embarrassed because of some basic fact I discover that I am unaware of. For instance: I only came to discover the practice of letter-spacing about four

years ago. (I can hear a collective intake of breath from the design community.) I'm ever stumbling on new facts regarding grids, kerning, color... (This is the curse of the autodidact: you simply don't know *what it is you do not know*.) What I taught myself back when I was leaving the piano was nothing you could really hang your hat on—little more than the rudiments of Quark, and a tiny bit about the production process. I learned just enough to get myself hired to do a handful of low-profile, pro bono jobs. This work made up the material for my first and only portfolio.[5] These jobs weren't particularly interesting or compelling in any way except that they became, each one, an excuse to learn a particular design task. One unpaid job would be my *Introduction to Picture Boxes;* another would be a *Typography 101.* In agreeing to do this work, I had locked myself into a course of study, which was how I acquired a modicum of proficiency not only in design, but also in the affiliated disciplines of production, illustration, and photography.

The first portfolio—when I dust it off and look on it now—is shockingly wince-inducing. The work is pretty consistently *awful.* (Can we see it, you ask? No. No you cannot.) The Knopf and Vintage art directors who interviewed me for my first job must have been drunk or otherwise mentally impaired when they decided to give my work, and my future as a designer, a big thumbs-up. It's clear to me now that a *large gamble* was taken. Though one has to assume that there must have been something positive there in my book—some germ of taste or talent—I don't really see it, and now, looking back over these pieces, this juvenilia made in my thirties, I shudder.

Nevertheless, something got me hired, and I'm pretty certain it wasn't my facility with baroque counterpoint.

One evening around the time of this career transition, I had dinner with my mother. We were discussing my recent spastic forays into the field of design and she said something like: "Well, you know I have a friend, who has a friend, with whom she plays scrabble, and *his* partner is a book designer. His name is Chip. I don't really know much about him—she says he's a big fan of Batman."

5 My first and only design portfolio:

 1. Two logos for two different friends—one who was starting a zine which never took off, one who was starting a small production company (he's now in construction).

 2. Five CD packages for small acts who happened to record their albums at the same studio where I had recorded as a pianist (the studio employed me on a *very skeptical* trial basis). 3. A poster and mailer for a Dominican thrash band. 4. A letterhead for my mother. 5. A tee shirt. 6. An identity for an amateur clothing line started by a friend of my cousin's.

Glamour!

(Well he sounds just *great,* Ma.)

I was given this "Chip's" phone number, and despite thinking that a) there is no more ridiculous job than *book cover designer* and b) nothing would come of meeting with him, I concluded that I had nothing to lose except an hour of my time. So I made the call. Before I knew what was happening I'd been granted an audience with (what I subsequently learned was) *a big design cheese.* Of course I didn't know at the time that I was scheduled to kiss the ring of the book design pope. I had written Chip off as a guy with a strange name, who did strange work (who would tell me about his strange job, and I would politely listen and that would be that). Of course, I had it all wrong.

But I will politely withdraw for a moment and let Chip tell this bit himself…

Okay, so here's what happened. At some point in 2003, my dear friend called me at the office.

"Hello?"

"Chip, do you have a moment?"

Now, I've found that when someone prefaces the conversation with, "Do you have a moment?" it's just not about anything that will benefit you in any way. You never hear:

Do you have a moment? You've won the lottery!

or

Do you have a moment? It's me, the guy you were ogling on the subway. Let's have dinner!

or

Do you have a moment? All the tests are negative!

So I braced myself. "Sure."

"Well, you remember Judy Mendelsund's son, Peter." Judy was her friend—a lovely, sweet, *patient* woman. "Peter," she repeated, "the pianist?"

Uh, no. "Sure."

"Well, he doesn't want to be a pianist anymore. He wants to be a graphic designer."

Oh, no. "Really."

"Yes, and, well…I promised Judy I'd ask. Could he come see you, and get some tips?"

Ugh. I could not tactfully say no. Cut to:

On an afternoon in 2003, a kid in his early thirties who looked like a younger version of Judy with scruff (this is a compliment, trust me) sat in my office,

portfolio in hand.

I'm thinking: *He gets a half an hour. I will somehow manage to come up with encouraging advice. And then my friend really, really owes me one.*

So I opened his portfolio, and then something that never happens, happened.

It was the graphic design equivalent of finding a great novel in the unsolicited manuscript slush pile. I can't specifically remember what the pieces were, other than maybe half a dozen CD designs for some of his friends' bands. But they were beautiful. Actually, "beautiful" didn't do the work justice, but the point was that he "got it," and without any formal training. It was so obvious.

Not only that, but we (the Knopf art department) actually had an entry-level job opening at the time. So I referred him to Carol Devine Carson (my boss and the V.P. and Art Director), who was also totally wowed. And she referred him to Vintage art director John Gall, and the rest, as they say...

It would be thematically tempting to conclude this with something like, "So now is Peter Mendelsund's moment." But that would be inaccurate. It's not a mere moment. It's an inspiring and inspired career that's been thriving for well over a decade, and it's just heading into its next phase. As I write this, I can't wait to see this book.

As for us at Knopf—hey, when my friend called, we actually *did* win the lottery.

—Chip Kidd

<div align="center">***</div>

So, reader, I was hired. As Chip mentioned, during my initial visit to the Knopf offices, then at 299 Park Avenue, Chip generously presented me to Carol (she of the *Autobiography of Red* jacket and the creative director of the entire department), and then to John, the art director of Vintage Books. After having met these three—these kind, literate, mordantly funny, and hugely talented people—I knew that there was nowhere else on God's green earth I'd rather work. It took another agonizing week for John to call me and offer me the job at Vintage as a junior designer, but when the call came in I was ecstatic. This particular endorsement felt, as you can imagine, so much better than the ceaseless self-loathing I was growing accustomed to. Someone wanted to hire me! To *pay* me...to read and to design books!

Incredible.

<div align="center">***</div>

During the first few weeks in my new cubicle (with my new Random House ID which certified me as a productive member of society, my new solitary rubber plant, and my brand new swatch books), I was unable to perform any of the tasks assigned to me without assistance. I was constantly pestering the other designers: "What's a Pantone chip? What's a mechanical? What's a stock agency? What does CMYK mean?" Everyone was so patient. And I was happy beyond belief. At 40K a year it was the most exhilarated I've ever been at a job—before or since. At first I was working solely on other designers' covers—making back ads and spines, doing paste-up mechanicals...but after about two weeks, John finally assigned me a title to design myself. It was the paperback version of a book by Edward O. Wilson entitled *The Future of Life.* There was one catch (there almost always is), and it was that the author had specifically requested that I employ a painting which he felt properly represented his text. And here is that painting. "Use this," I was told:

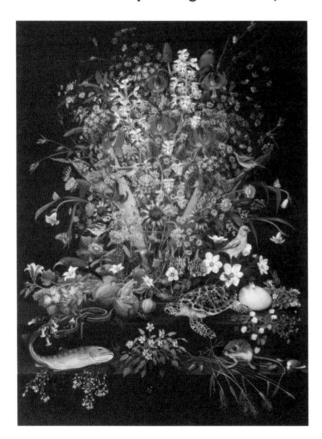

Not so bad, right?

Well, if you are a cover designer, this lovely painting, though compelling on its own, is a complete nightmare to work with. There's no particular place to rest your eye, there's no decent location for the (considerable amount of) copy, it is unclear, without additional commentary, what this cacophony of creatures and plants might have in common with one another, the colors are all over the map, the whole thing is massively confusing... So, what to do?

I only bring up this particular Vintage cover kerfuffle because the answer to this problem, my first *design* problem became, for me, a methodology. My solution turned out to be a prototypical one. Making a passable cover out of this painting was my first exposure to a practice that I now employ on a regular basis...

The process is as follows:

1. Pick a small detail out of something large, unwieldy, and compound.

2. Allow that small detail to serve as an emblem for the whole.
Normally, the "something large, unwieldy, and compound" is the narrative itself, the entirety of the author's work that I've been charged with jacketing.
The "small detail" is normally a charac-

ter, place, scene, or object *from* that narrative. Finding that unique textual detail that, as the subject matter for a book jacket, can support the metaphoric weight of the entire book, is now the substance of my work. When I read a manuscript now, it is with this unusual task in mind. In this case, all I had to do was find a decent visual detail in the painting. As you can see here, I proposed a die-cut cover in which the entire painting, minus the little orange frog, was occluded, leaving just that tiny amphibian reminder of the risk implicit in Wilson's title.
In retrospect I'm surprised that there was room in the budget to use a die-cut. But I was too ignorant to know *not* to ask (another of my *methods*). It was approved and printed.

So: my first cover.

Within a couple of months I was asked by Carol to design a hardcover jacket—my first hardcover jacket.

It was for a book (all too fittingly) called (*sob*) *Chopin's Funeral.*

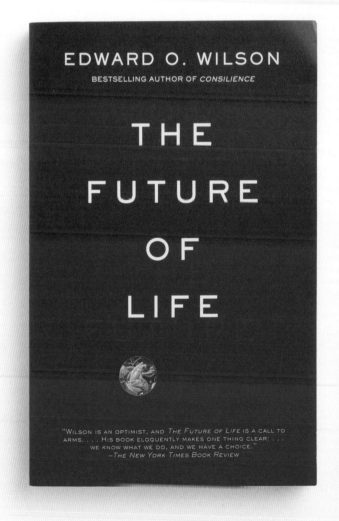

And then eleven years went by. And here we are. Now.

So—why a design monograph? Why the book you are currently reading?

It occurred to me, a couple years back, that design careers follow a certain inevitable path, and that upon this path there are certain compulsory benchmarks. Namely, after producing enough passable design to have established a reputation—and after having participated in the requisite interviews, given the obligatory talks, joined the boards of the necessary organizations—it is de rigueur that a designer then publish a book of his or her work.

A monograph. A *design* monograph.

A design monograph is a peculiar kind of book. Most books of this sort will assert that they are "by" the designer in question—though often this attribution is misleading. The work shown in a design monograph will be (hopefully, exclusively) "by" that designer, but this doesn't mean that the book is "by" the designer; at least not in the same sense that, say, a novel is "by" a novelist. There are exceptions, but most design books of this sort are really just compilations, collections, showcases. Often these design books seem no different than a design portfolio. Not that there is anything intrinsically wrong with a design portfolio in book format, it's just the "by" part of the equation has always felt a little off to me.

(A book, I thought, rather smugly, should be a *book*—i.e. it should be *written*; and it should furthermore be written…*by its author.* This is, admittedly, a personal prejudice.)

For this, and other reasons, mostly mysterious to me, the whole idea of making a design book felt vaguely distasteful. And I certainly hadn't, in the past, been interested in publishing one of my own.

The making of this book, *Cover*, wasn't, in fact, my idea (as if that excuses it). I was approached by powerHouse Books, who had the idea that I should compile

a collection of my own work, and thinking that this was the expected thing—I agreed, if only so that I could now have a portfolio which supersedes and supplants that first portfolio, my "student" portfolio, the one I put together all those years ago and can no longer bear to countenance.[6] Also, I recall, very clearly, only now, after having committed myself to the publication of this book, that it was precisely this kind of design book that helped me become a designer in the first place. Without any formal training, and without the time or money to acquire any, I was forced to haunt the shelves of various outlets of the then-newly-resurrected Barnes & Noble franchise. There used to be an entire design section in these stores. (Is there still?) There, at B&N, I bought "how-to" books: manuals on the various software I'd need to know how to use, but also books made up of the design work of others—either volumes like, say, *Best Business Cards, 2003!* or *Stellar Identities!*, or else anthologies of the work of one or another particular designer. I learned, like most designers do, through looking.

See, this was how a person used to experience much of the interesting design work being produced—in book form. Sure, there was the work that was impossible to miss, the ubiquitous "big campaign stuff"—but for the more esoteric brand of design, these books were all we had. The internet, of course, has since, to some extent, obviated the need for such books. (Though that doesn't mean they aren't fun, and useful, to own. The more time passes, the more I have come to believe, against prevailing opinion, in the lasting value of the physical book.)

In any case, the putative obsolescence of design monographs doesn't help explain why I had developed such distaste for the genre. Why had I resisted the idea of making one so? Why, and when, did the idea of making a design book become anathema to my delicate sensibilities?

Well, nobody wants to seem like they are tooting their own horn. A book of one's own work seems like bragging; preening. It is bad manners; in poor taste. Not to mention there are many more worthy designers than me who deserve this "monograph treatment."

But there is still another, deeper origin to my disinclination towards making my own design book. Upon reflection, I recently determined that I seem to have been hedging, and still am hedging, even after all these years, about calling myself a "designer" at all.

I don't think I've ever fully warmed to the idea of design as a profession—I have

6 Perhaps I'll finally get to throw it away?

never completely self-identified as a designer. (I'll not plumb the twisted psychology of this here, but it obviously has something to do with being obliged to leave my old career, music.) But suffice it to say that somehow, despite all this time I've spent designing, I had still been thinking about design as a stop-gap occupation between being a pianist, and being some glorious third thing altogether. And here is yet another possible implication of my book's title. A cover is also an *alias*—a temporary identity under which lies one's true(er) self.

Peter Mendelsund, musician, AKA "book designer."

But perhaps the publication of this book is a bit of an admission; a surrender to the obvious; a statement of intent; a clarion call to myself that perhaps what I am is what it says I am on my business card.

(We are all, in fact, not that which we *hope to be,* but rather that which we *actually do*.)

So, in case it wasn't evident before: I am a designer. Hopefully this book will help convince (I'm less concerned about *you*, but rather…) *me*, this book's author, of this assertion. I am a designer.

I am a designer.

My name is Peter Mendelsund, and I am a designer.

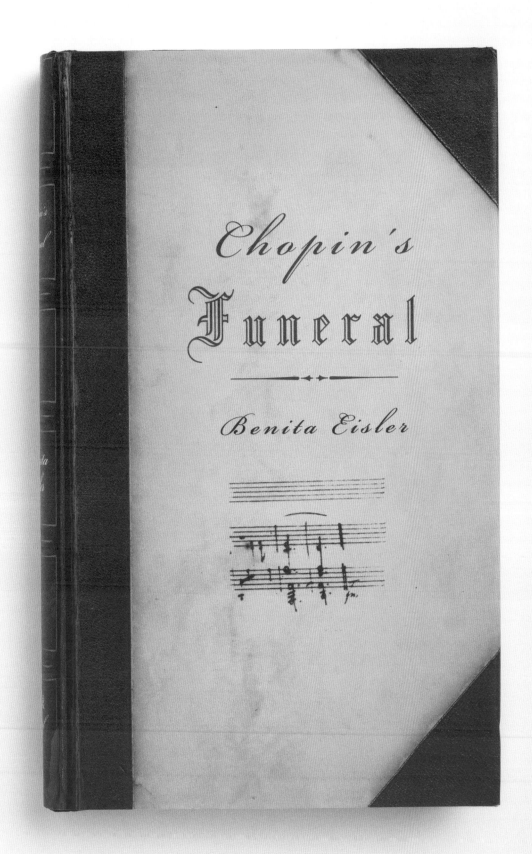

My first-ever hardcover jacket and the beginning of my career at Knopf.

Two final notes for a reading of this book:

1. To *cover* can mean to travel a certain distance, to pay for, to camouflage, to describe or comment on, but it also can mean to comprehensively include. This book is *not* comprehensive. It does not contain *all* of my work. What is covered here is but a very small fraction of the book jackets and covers I've worked on. Also not included here: large categories of my design output including my editorial illustrations, magazine covers, branding, advertising, and (most painful of all to omit) music packaging. I considered making a book that was *all of it,* the whole kit and caboodle, but then imagined that you the reader might find it confusing and thus decided against it. This book is therefore a book of *book-work.* Not *all* the book work, but still.

2. Any time I've included a cover that was killed—that didn't make it to fruition on the printing press—whether killed by dint of a client's caprice (or good sense) or culled by my own hand, there is a red X to indicate this status.

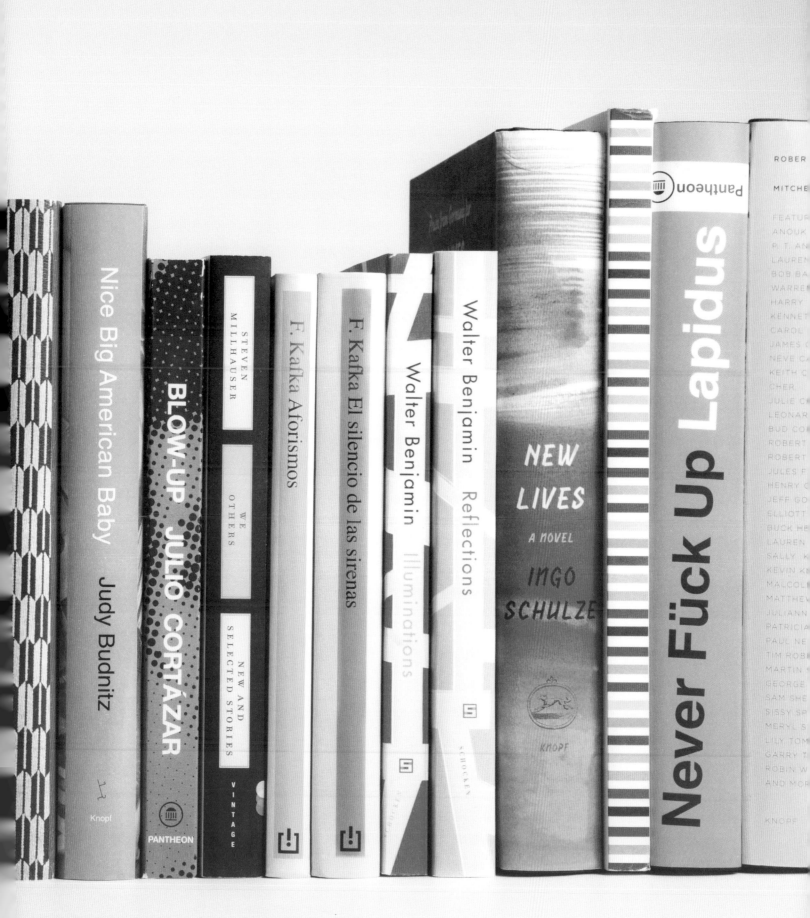

Nice Big American Baby — Judy Budnitz — Knopf

BLOW-UP — JULIO CORTÁZAR — PANTHEON

STEVEN MILLHAUSER — WE OTHERS — NEW AND SELECTED STORIES — VINTAGE

F. Kafka — Aforismos

F. Kafka — El silencio de las sirenas

Walter Benjamin — Illuminations

Walter Benjamin — Reflections — SCHOCKEN

NEW LIVES — A NOVEL — INGO SCHULZE — KNOPF

Pantheon

Never Fück Up — Lapidus

ROBERT
MITCHE

FEATUR
ANOUK
P. T. AN
LAUREN
BOB BA
WARREN
HARRY
KENNET
CAROL
JAMES
NEVE C
KEITH
CHER
JULIE C
LEONAR
BUD CO
ROBERT
ROBERT
JULES F
HENRY C
JEFF GO
ELLIOTT
BUCK HE
LAUREN
SALLY K
KEVIN K
MALCOL
MATTHE
JULIANN
PATRICIA
PAUL NE
TIM ROB
MARTIN
GEORGE
SAM SHE
SISSY SP
MERYL S
LILY TOM
GARRY T
ROBIN W
AND MO

KNOPF

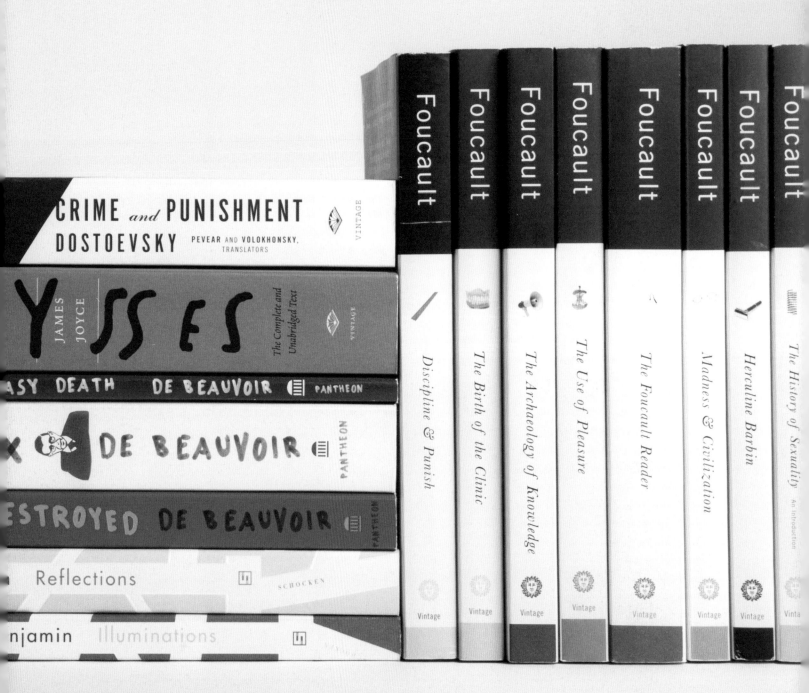

Classics

My initial sketch for the redesign of ILLUMINATIONS and REFLECTIONS — in which Benjamin's flâneur
is provided with a stylized set of streets to wander; each street being named after one of his essays.

3

Walter Benjamin

Reflections

hashish in marseilles

karl kraus

New preface by Leon Wieseltier

theologico-political fragment

Edited by Peter Demetz

Essays, Aphorisms, Autobiographical Writings

the author as producer

a berlin chronicle

surrealism

fate and character

on language as such...

critique of violence

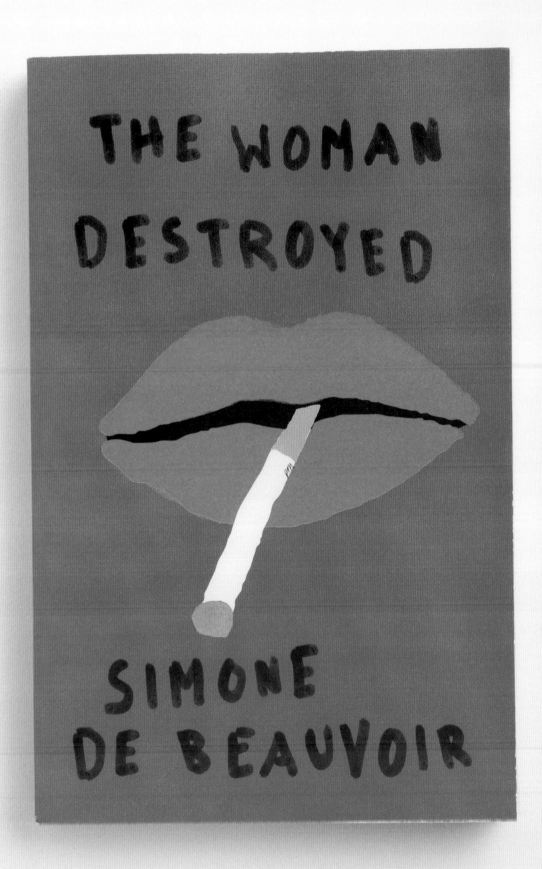

A *femme rompue* is a decidedly bad thing to become.

"A shocking success that may be traced to its eye-catching cover." —THE NEW YORK TIMES, 12/15/13

The only book of
Simone de Beauvoir's
that Sartre did
not read, edit, and
(one assumes)
approve, first.

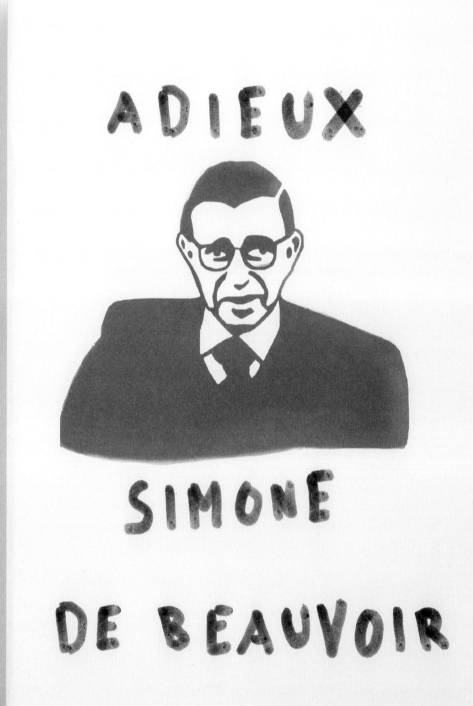

These cover
designs for Simon
De Beauvoir's
Pantheon backlist
were inspired by
the *affiches* and
wall stencils of
the 1968 Paris
riots. I wanted a
style with a
certain directness—
and I liked the
idea of co-opting
the visual language
of this revolution
for a writer who
was nothing if not
(philosophically,
politically)
revolutionary.

I also wanted
covers that weren't
overtly *sexed*.
(Not covers that
were un-"sexual,"
but rather, covers
that were unfixed
on the male/female
axis). I certainly
did *not* want to
employ any of the
tropes normally
given to "woman
writers." Espe-
cially not for this
author. I wanted
the covers to
be striking, but
not "pretty."
(The cover for
THE WOMAN DESTROYED
is as close as
I've ever come to
a "jolie-laide"
cover—and I love it
for that reason.
I've certainly
made *ugly* covers
before; and I hope
that I've made
pretty ones.
But it's the uneasy
balance of both
attributes that I
enjoy in this
series.)

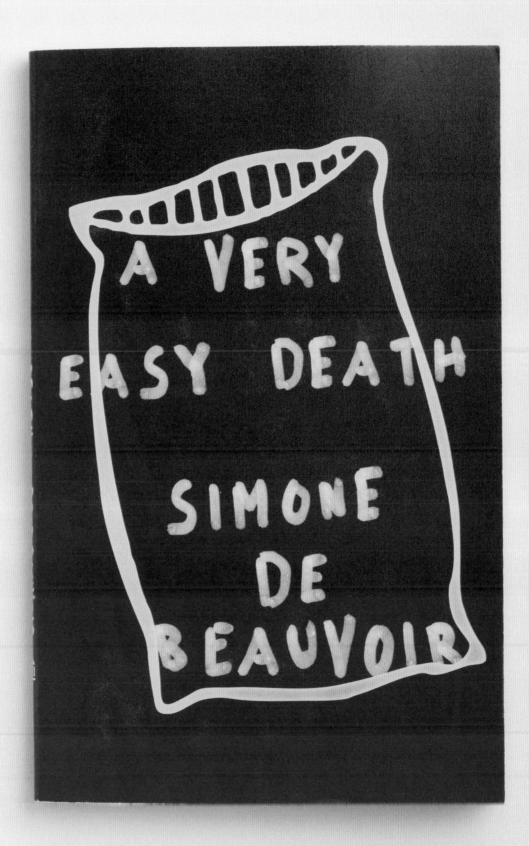

"You do not die from being born, nor from having lived, nor from old age. You die from something...
Cancer, thrombosis, pneumonia: it is as violent and unforeseen as an engine stopping in the middle of the sky..."
—S. de Beauvoir

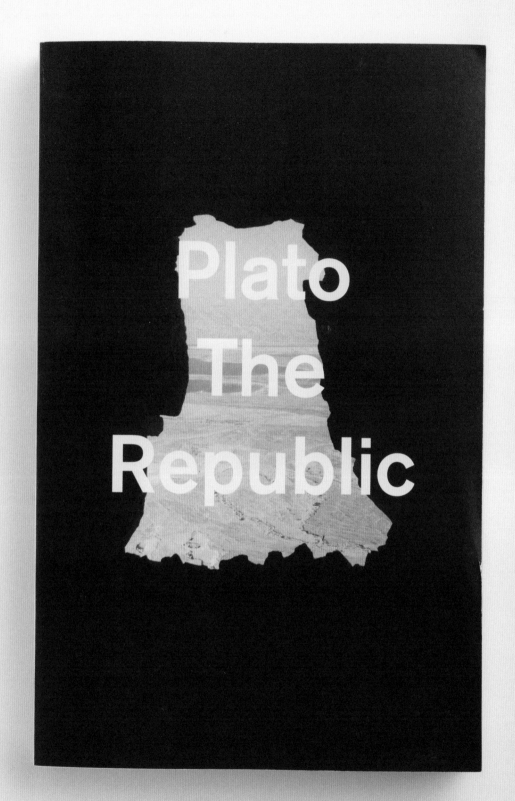

"Any one who has common sense will remember that the bewilderments of the eyes are of two kinds, and arise from two causes, either from coming out of the light or from going into the light." —Plato

×

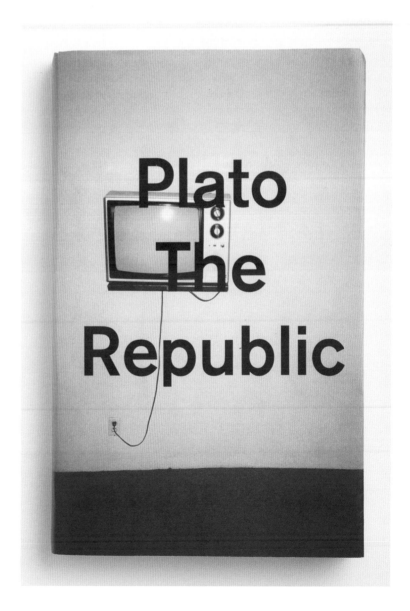

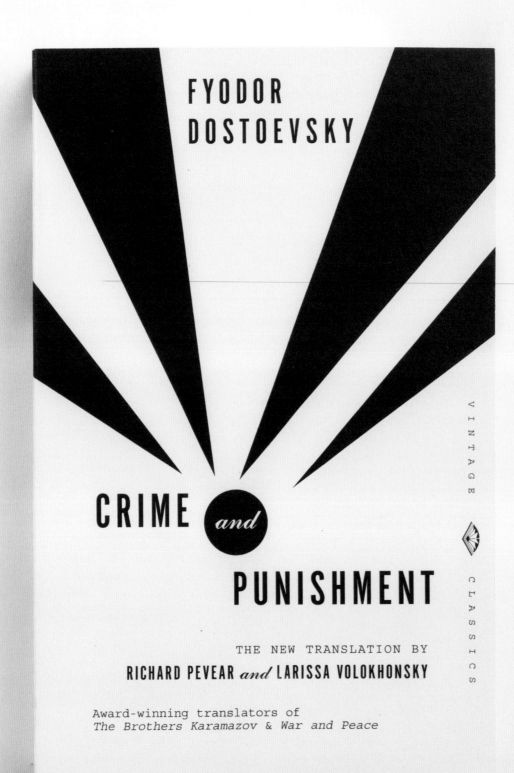

FYODOR
DOSTOEVSKY

CRIME *and*

PUNISHMENT

THE NEW TRANSLATION BY
RICHARD PEVEAR *and* LARISSA VOLOKHONSKY

Award-winning translators of
The Brothers Karamazov & War and Peace

VINTAGE CLASSICS

My favorite book jackets have always been abstract jackets (specifically those of Alvin Lustig's, George Salter's, John Constable's). When I first began in the field, there were hardly any abstract covers being made any more, and none for the classic backlist. Most book jackets were mimetic and photographic, and I felt like we had skewed too far in the direction of literalism and over-specificity. I distinctly remember thinking that it was high time for a return to the *old ways*. So I made these Dostoevskys.

FYODOR DOSTOEVSKY

VINTAGE CLASSICS

DEMONS

THE NEW TRANSLATION BY

RICHARD PEVEAR *and* LARISSA VOLOKHONSKY

Award-winning translators of
The Brothers Karamazov & War and Peace

And they opened up the floodgates for more like them. Since I first made this group, this abstract illustrative approach to series design has become fairly commonplace. ("Imitation = flattery" I suppose.) Perversely, now given the ubiquity of this style of book design, I feel the tug back towards photography and mimesis.

FYODOR DOSTOEVSKY

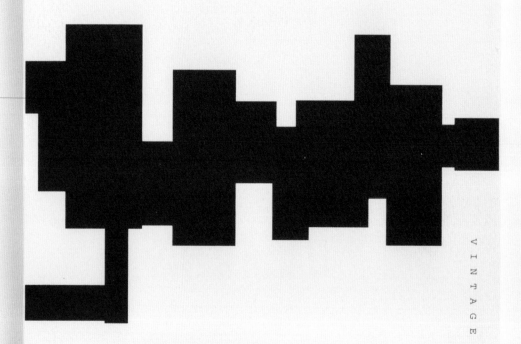

NOTES *from* UNDERGROUND

THE NEW TRANSLATION BY

RICHARD PEVEAR *and* **LARISSA VOLOKHONSKY**

Award-winning translators of
The Brothers Karamazov & War and Peace

VINTAGE CLASSICS

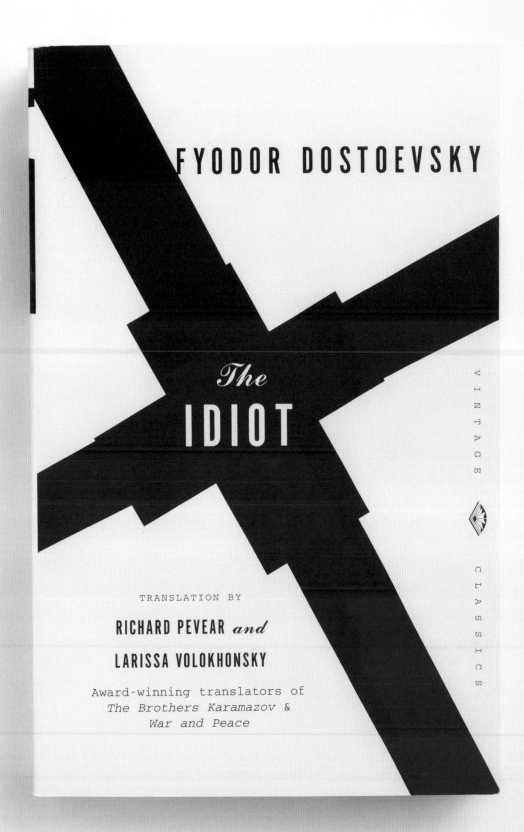

FYODOR DOSTOEVSKY

The
IDIOT

TRANSLATION BY

RICHARD PEVEAR *and*

LARISSA VOLOKHONSKY

Award-winning translators of
*The Brothers Karamazov &
War and Peace*

VINTAGE CLASSICS

This cover was the first in the series. After designing THE IDIOT, I practically had to beg Vintage Books to repackage the others. Eventually they relented. The cross, (or X), like the Christian crucifix, gives us both a symbol of the Christ figure as well as a symbol of his undoing or negation. (In this case, the Christ figure is doomed epileptic Prince Myshkin.)

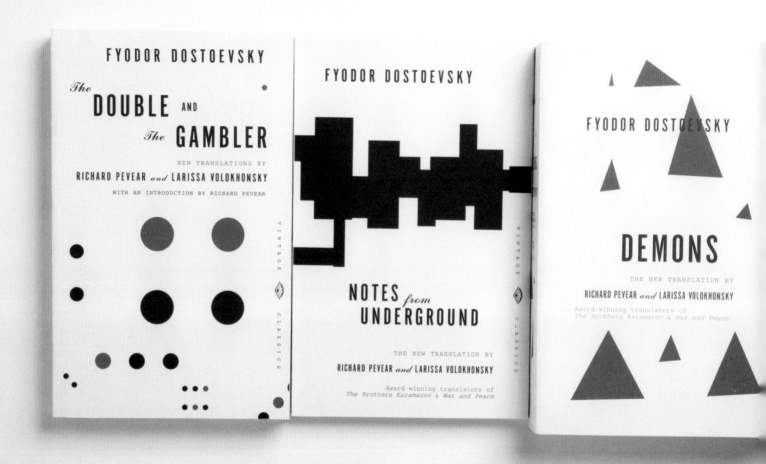

"There is no subject so old that...

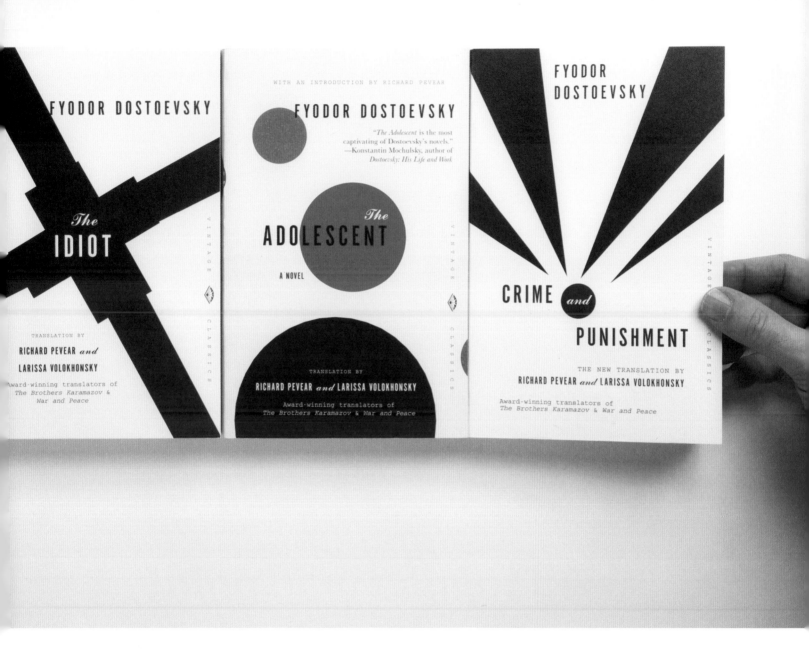

something new cannot be said about it." —F. Dostoevsky

"Anyone who doesn't read Cortázar is doomed. Not to read him is a grave invisible disease which in time can have terrible consequences. Something similar to a man who had never tasted peaches. He would be quietly getting sadder, noticeably paler, and probably little by little, he would lose his hair. I don't want those things to happen to me, and so I greedily devour all the fabrications, myths, contradictions, and mortal games of the great Julio Cortázar." —Pablo Neruda

(For more on the genesis of this cover, you can skip to "The Anatomy of a Cover," on page 237.)

Hopscotch

a novel

Julio Cortázar

TOLSTOY

The Death of Ivan Ilyich & Other Stories

A NEW TRANSLATION BY

PEVEAR & VOLOKHONSKY

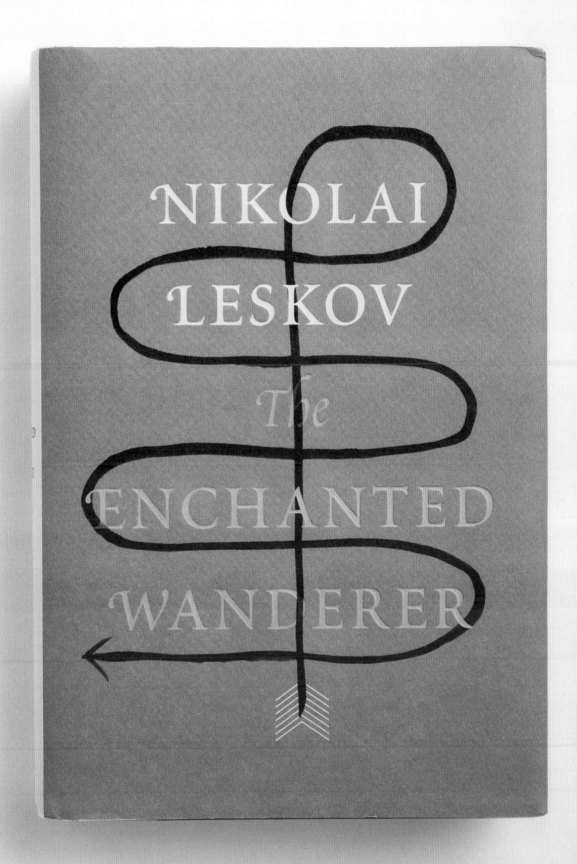

A jacket which addresses narratology, and the manner of telling, rather than the facts of the narrative — i.e. Leskov: The digressive, meandering, "Storyteller."

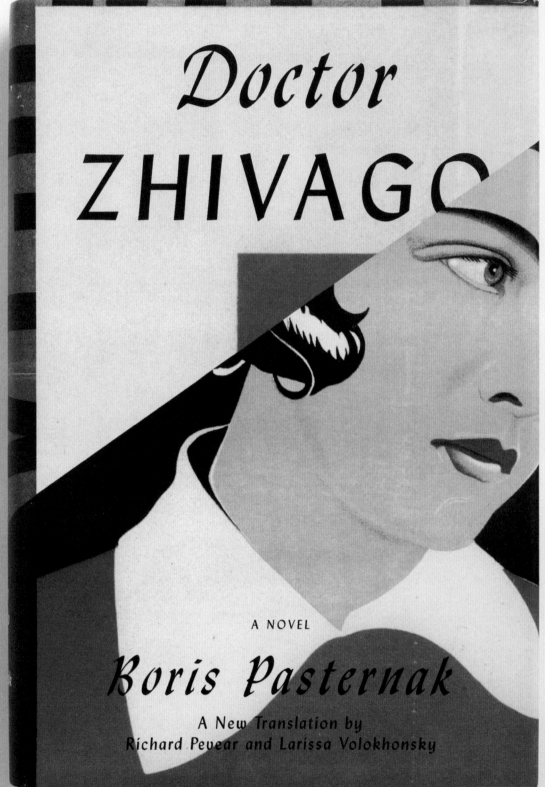

For better or worse, Americans tend to associate this book with David Lean's film and, more specifically, with Julie Christie and Omar Sharif. It seemed, cynically, like the best way to sell the book was to subtly reference the matinee-idol aspects of the movie without giving the cover a strictly *Hollywood*-style treatment. In other words, the jacket had to look big and character driven rather than the usual "kulaks in the snow" kind of deal. The main illustration is from a Soviet propaganda poster that was deployed in the implementation of the Five-Year Plans, and it is oddly very filmic. I suppose selling a film is in some ways like selling a monumental and ultimately catastrophic agrarian reform. In fact, the similarity between Soviet socialist realist propaganda and Hollywood publicity probably constitutes the subject of some-one's doctoral dissertation somewhere.

P&V's edition of WAR AND PEACE landed Tolstoy back on the best-seller list. Without even needing the intercession of Oprah.

"I was a Flower of the mountain yes when I put the rose in my hair like the Andalusian girls used or shall I wear a red yes and how he kissed me under the Moorish Wall and I thought well as well him as another and then I asked him with my eyes to ask again yes and then he asked me would I yes to say yes my mountain flower and first I put my arms around him yes and drew him down to me so he could feel my breasts all perfume yes and his heart was going like mad and yes I said yes I will Yes." —J. Joyce

Ulysses

James Joyce

Choosing Colors

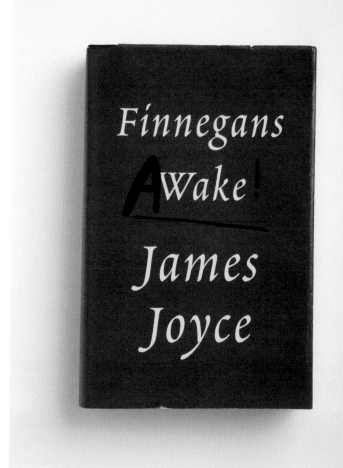

"Erin, Green Gem Of The Silver Sea." Green for Parnell. *Portrait* is red. Red: the rising of youthful blood. (Maroon for Michael Davitt.) But *Ulysses* should be the color of Greek flag (the author decreed it. Joyce brings a cloth sample to the printer in order that they should match the hue precisely. Later, at a party, he brags to his friends: The *perfect shade*.) But then again, green: "Gazing over the handkerchief, he said: 'The bard's noserag. A new art colour for our Irish poets: snotgreen.'" A "snotgreen sea" (not a winedark sea) is the setting for Bloom's odyssey. "The ring of bay and skyline held a dull green mass of liquid." "A cloud began to cover the sun slowly, wholly, shadowing the bay in deeper green." Green *books* even: "Remember your epiphanies written on green oval leaves, deeply deep, copies to be sent if you died to all the great libraries…" Then there's the "green" flashing eyes. (Not once, but *twice*. And one green fairy fang.) Sandymount Green…"green sluggish bile…" I visit a rare book collection and handle a Sylvia Beach first edition; which isn't, in fact, blue. It's somewhere between a Persian green and a *mint*. Age? Exposure to the elements? Hard to say: But it's clinched. *Ulysses* is *green*. *Portrait*, again, is a rustier red; a maroon. The velvet maroon of the governess' brush. The *Wake* is black as the monstrous, logorrheic, cacophonous nightdream itself. Black of night; black of mourning. Black as Typhon ("Keep black, keep black!") Obviously: *black*. The *Pomes* are "Rosefrail and fair." Maybe "the noon's grey-golden meshes?" What is a gray gold? A golden-delicious *pomme*. *Dubliners*? The color of the evening invading the avenues while Eveline looks on—a smell of "dusty cretonne" in her nostrils. The color of fatigue, of Araby's day becoming late; *too* late… What is the color of regret? The color of the cold—the cold night skies when snow is faint and morning close. "Blue o'clock the morning after the night before," we are told. "What spectacle confronted them when they, first the host, then the guest, emerged silently, doubly dark, from obscurity…the heaventree of stars hung with humid nightblue fruit." Nightblue.

"Snotgreen, bluesilver, rust: coloured signs."

Portrait of
AS A
The Artist
YOUNG
James **MAN**
Joyce

Ul**ysses**
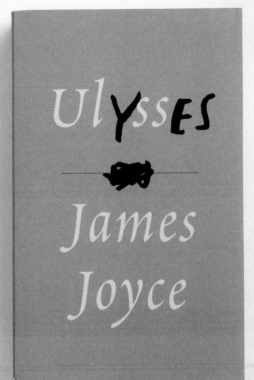
James
Joyce

Po**⊗**mes
PEN**YE**ACH
James
Joyce

Dublin**ERS**
James
Joyce

Providing a metric of, and implement for: punishment.

Michel Foucault

Discipline & Punish

The Birth of the Prison

fig. 12

Michel Foucault

The Archaeology of Knowledge

And The Discourse on Language

fig. 43

The statement, or *énoncé.*

"What strikes me is the fact that in our society, art has become something which is only related to objects, and not to individuals, or to life."
—M. Foucault

On the politics of gender identity.

Boing. Boing.

Michel Foucault

The History of Sexuality

Volume 1: An Introduction

fig. 4

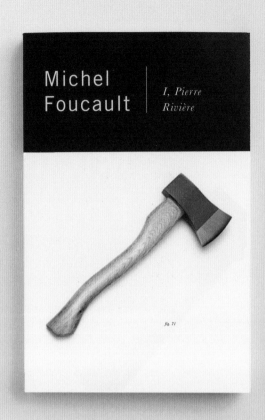

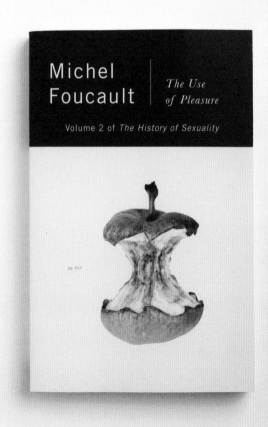

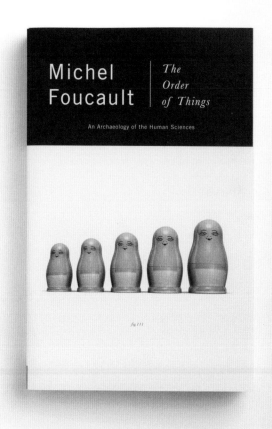

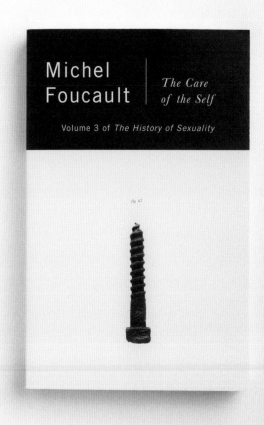

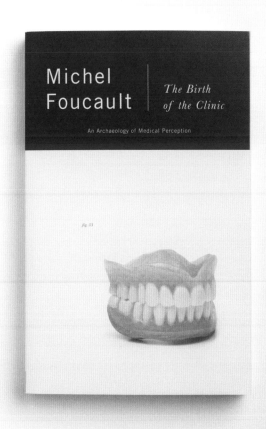

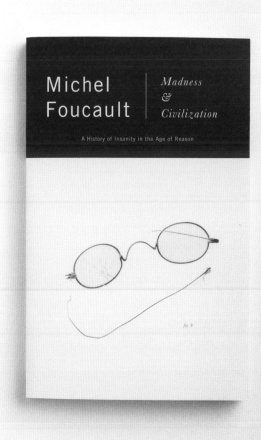

By Jane Mendelsohn

Seeing Kafka

"When Eduard Raban, coming along the passage, walked into the open doorway, he saw that it was raining. It was not raining much."

These two sentences are from Kafka's early, unfinished story "Wedding Preparations in the Country." These sentences are also the epigraph to John Ashbery's astonishing poem "Wet Casements," a poem about, among other things, perception, vision, consciousness, and reading and writing as visual, psychological, and emotional acts. Ashbery's poem is an extended commentary on these seemingly banal sentences from Kafka, which are revealed to be far from simple.

Look at them closely. In the first sentence we are given a visual description of Eduard Raban—coming along the passage, walking into the open doorway—and then a report of his visual experience: he saw that it was raining. In the second sentence Kafka tells us "it was not raining much." Who makes this evaluation? Kafka or Eduard Raban? It feels as we read these lines as if it is Eduard Raban's interpretation of the degree to which it is raining. Through Kafka's mastery and movement from the visual to the verbal, from the outside to the inside by way of the outside, we have slipped effortlessly into Eduard Raban's head.

Ashbery comments on these lines at the beginning of his poem: "The conception is interesting: to see, as though reflected in streaming windowpanes, the look of others through their own eyes." He is talking about, among other things, the way in which Kafka gets into Raban's perspective and shows us what Eduard Raban sees, and that Kafka does this by beginning with the visual. Notice that Ashbery uses the word conception, not concept. He is pointing out the conception, the beginning, the way in which Kafka gets into Raban's head and leads us visually to not only what he is seeing, but "the look of others through their own eyes." See. Reflected. Windowpanes. Look. Eyes. It's an incredibly complex sentence, itself reflecting on the visual nature of writing, reading, and consciousness.

The poem is also remarking on the impossibility, except through writing, of doing what Kafka has just done. We can't really see "the look of others through their own eyes." Only through the visual magic and profound empathy of

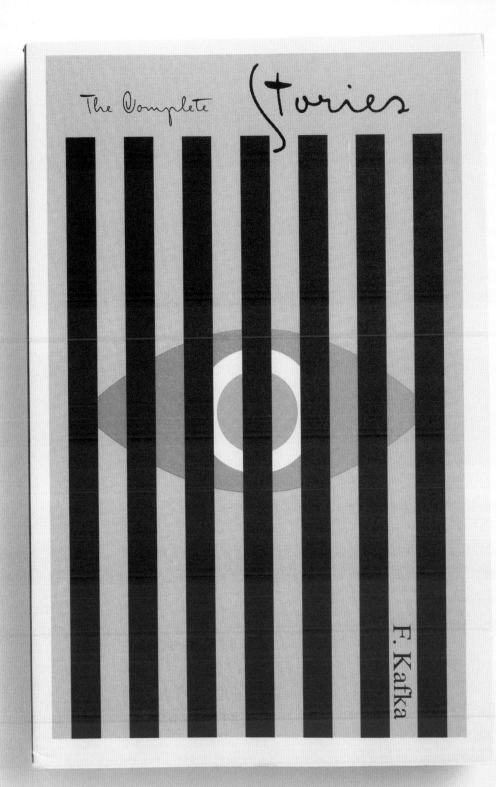

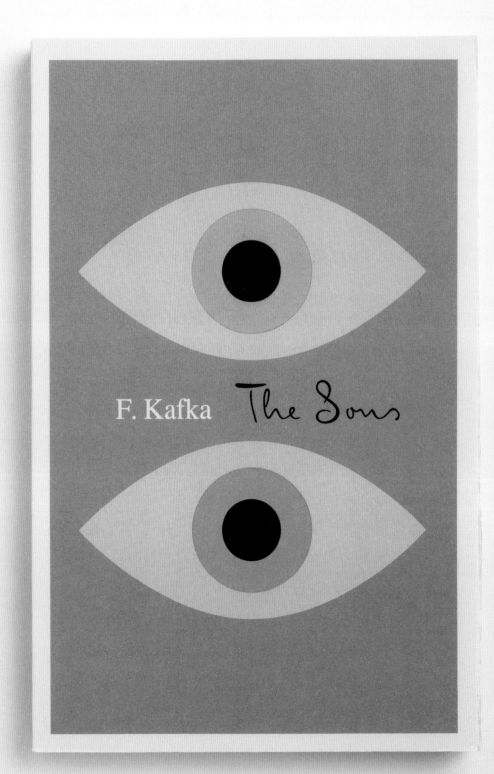

fiction can we create the experience of doing so. The poet both likes the idea and mocks the idea that we can ever gain this level of complete knowledge of someone else, especially of what they truly think of themselves or of others. "I want that information/ very much today./ Can't have it, and this makes me angry," he says later in the poem.

But this impossibility, recognized by both Kafka and Ashbery, does not have to stop us from communicating and connecting, or attempting to do so. Kafka said: "We photograph things in order to drive them out of our minds. My stories are a way of shutting my eyes." Shutting his eyes and opening ours. Similarly, Ashbery resolves his anger by deciding: "I shall use my anger to build a bridge like that/ of Avignon, on which people may/ dance for the feeling/ Of dancing on a bridge. I shall at last/ see my complete face/ Reflected not in the water but in the/ worn stone floor of my bridge."

The writer and reader will connect through the writing, through the physical, sensory, as well as intellectual act of reading and being read. And in this way a person can see him or herself.

OK, I think I've made my point: Kafka and Ashbery have deeply visual ways of understanding reading, writing, empathy, and consciousness. So does Peter Mendelsund. His Kafka covers seem to me to illustrate this understanding so perfectly that I think of them as the book cover equivalent of "Wet Casements." Wet casements are eyes and eyes are wet casements, windows both into the soul and opening outward, like Keats's "magic casements, opening on the foam/ Of perilous seas..."

Mendelsund's use of the eye as the motif for his Kafka covers can be read as illustrating the famous Kafka-esque paranoia, but I believe that is only the most obvious level on which they work.

The use of the eyes in the Kafka covers captures Kafka's profound visual sensibility and his awareness that we process the world and reading often as a visual experience, and that this is thrilling, boring, tragic, comic, and simply true. Recent neuroscience supports this thinking. In Eric Kandel's *The Age of Insight,* Kandel describes recent discoveries in brain science as revealing that we see things before we know we have seen them. That the time between seeing something and knowing it is filled with a filtering of memories, associations, and personal beliefs which then contribute to our awareness of what we see. This is not to say that nothing is real, just that each person's reality is a little (or more than a little) different.

What makes the visual aspect of writing also psychological and emotional, empathetic and individual, poetic and scientific, is that the writing and reading can reveal to us the process whereby we turn visual information into consciousness or, in other words, what we do with information we don't yet know we have. We see something and there is a space of time in which our brains interpret it. What happens during this time is specific and universal, beyond the visual and the verbal, the place that art is always trying to reach.

Peter's cover for Kafka's *Metamorphosis* realizes all of these ideas. The eye and the circle of insect skin, two casements, looking outward and inward, at the same time, these images deliver with expert compression, intellect, color, and visual delight the sense that Kafka's *Metamorphosis* is a masterpiece about perception, identity, and vision. What is the profound experience that Gregor Samsa has undergone? He looks different. And Kafka makes us see differently. And Peter Mendelsund understands that and captures it in a visual image as rich as a poem.

Have I mentioned humor? Kafka is a very funny writer. More than dark and foreboding, totalitarian or paranoid, surreal or nightmarish, Kafka is funny. It is said that when he read his stories aloud to his friends he laughed the whole time. His deep insights into the absurdity of the human condition are not simply tragic, they are comic too, and colorful. Mendelsund's colorful, playful Kafka covers get it. They manifest the ferocious intelligence that generates humor. Freud said that, "Humor makes the meaningful meaningless and the meaningless meaningful." This is a useful description of what is going on in Kafka.

Even the sublimely simple sentences about Eduard Raban are meant to be slightly funny: "It was not raining much." And the variations on the theme of eyes and seeing in Mendelsund's suite of Kafka covers, with their subtle distinctions and repetitions, their tonal contrasts of lavender and orange, red and green, delivered with such sophisticated wit, are meant to be slightly, or more than slightly, funny. Funny, smart, and beautiful.

All of Peter's covers are funny, smart, and beautiful. And all of them say something about the visual nature of reading, writing, and perception.

Each one is a poem. Look at them closely.

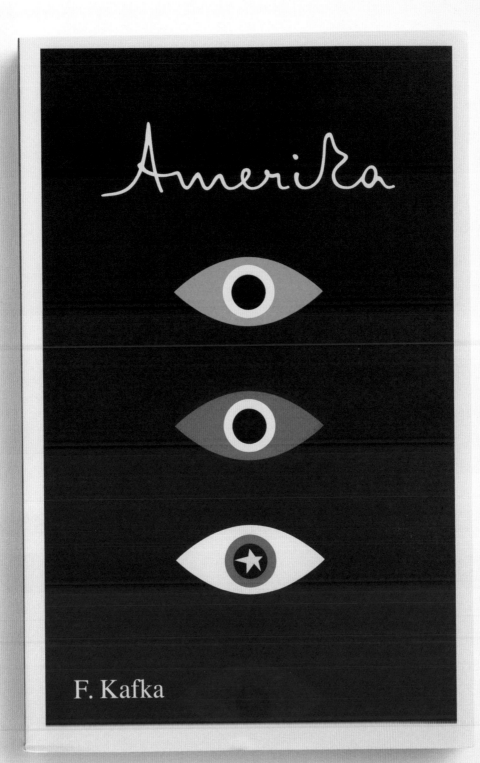

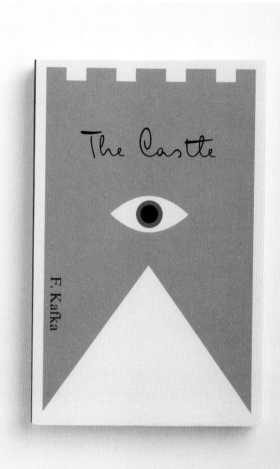

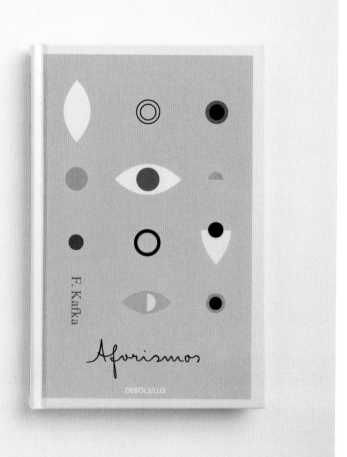

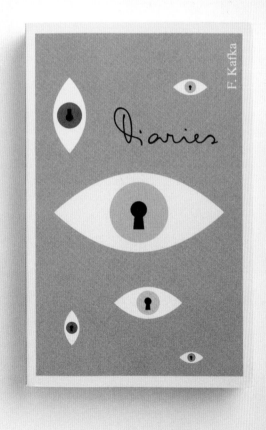

"The mystery of Kafka is so difficult to capture — he's both so exact/exacting and so difficult to pin down. I love the move to turn the gaze back at the reader, subjecting her to the same anxiety-producing scrutiny that dogs so many of Kafka's own characters."
—Susan Bernofsky

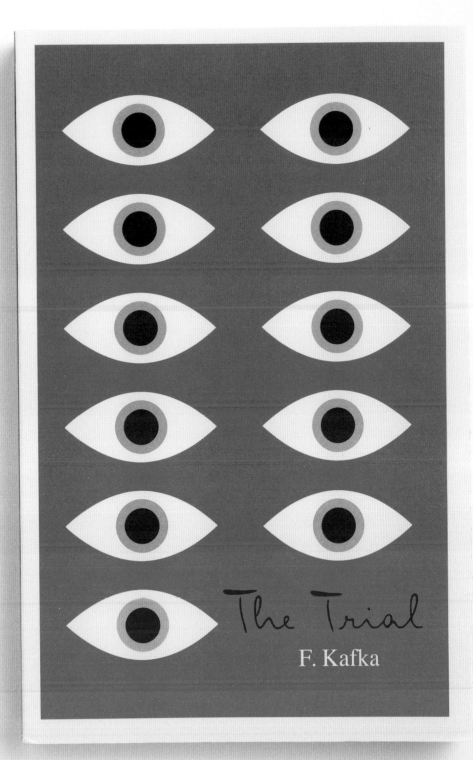

The idea for this cover sprang from reading a single line in THE TRIAL: "'You've got lovely dark eyes,' she said after they had sat down, looking up into K.'s face..." I was reminded, reading this, of an idea presented by Roberto Calasso, who suggests that Kafka's project in THE CASTLE and THE TRIAL hinges upon notions of (s)election and recognition. He points out that the land surveyor *K* desperately wants to be recognized by the castle (he seeks *election*) whereas *Joseph K* is, sadly for him, *selected* (for punishment). It was my inference that both these forms of recognition depend, in some crucial way, upon *difference*.

"It occurred to me…
that [the artist]
might want to draw
the insect itself.
Please, not that—
anything but that!
The insect itself
cannot be drawn.
It cannot even
be shown in the
distance." —F. Kafka
to his publisher

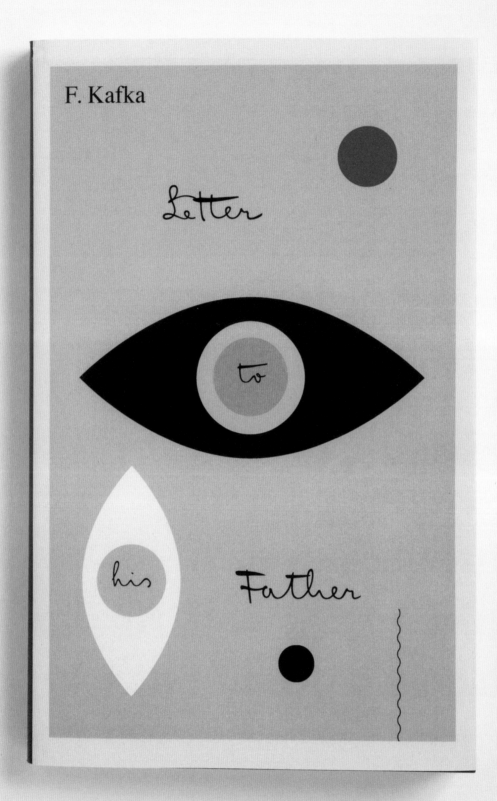

F. Kafka

Letter to his Father

The complete letters.

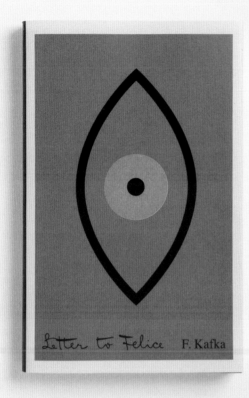

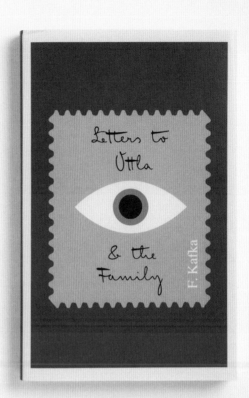

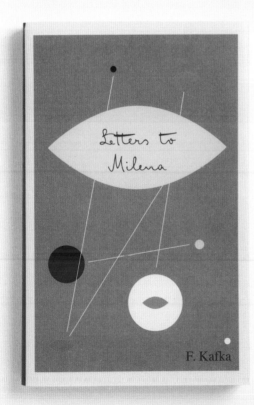

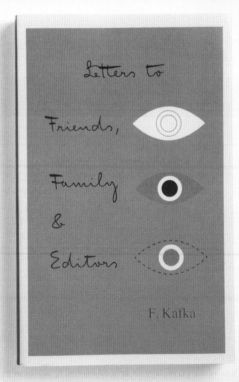

My initial notes concerning the Kafka redesign.
(BELOW)

44

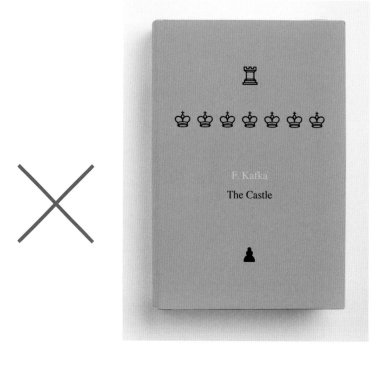

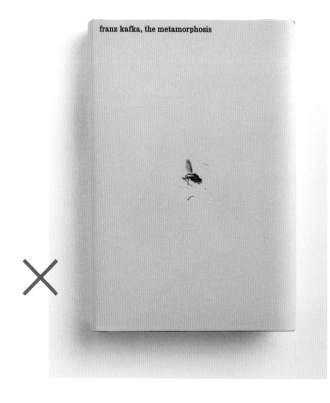

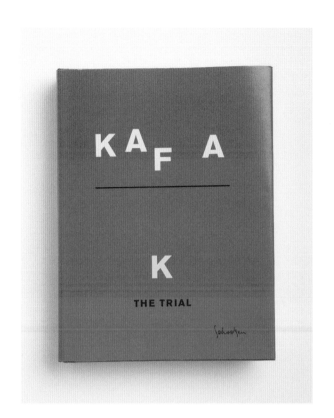

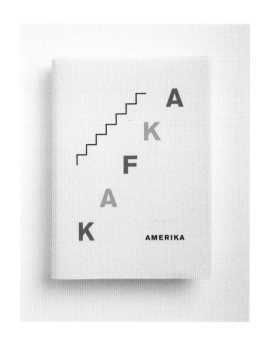

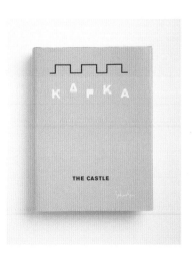

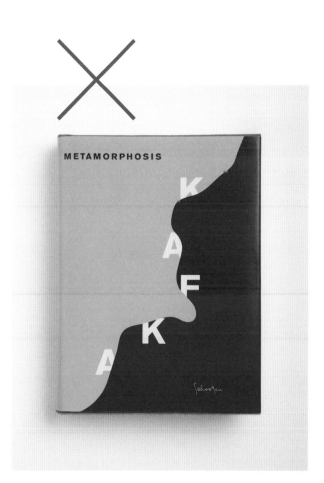

45

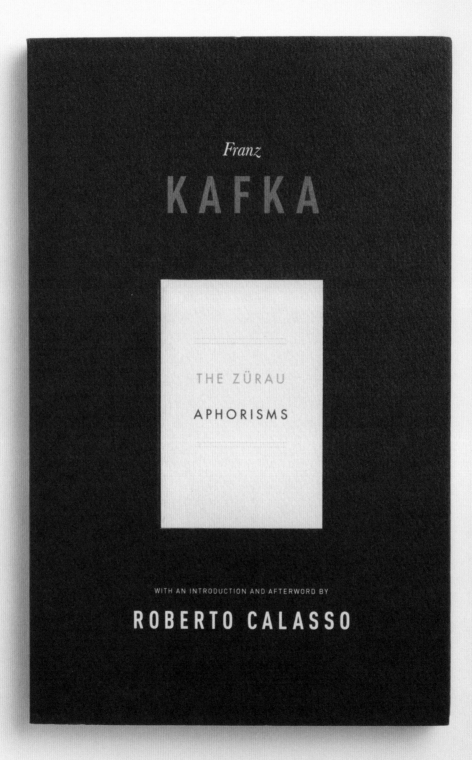

A cover embedded in a cover. The little "book" on the front is lightly scored, such that, over time, it opens, revealing an aphorism or Kafka's portrait, depending on the position of the flap.

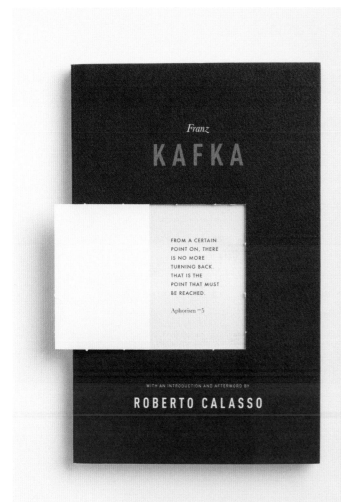

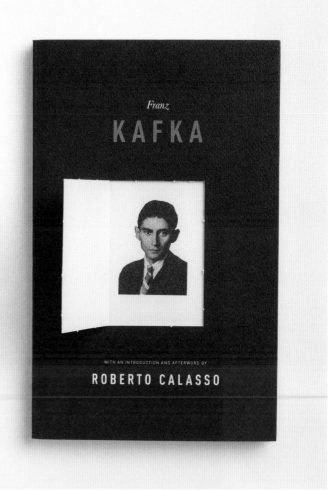

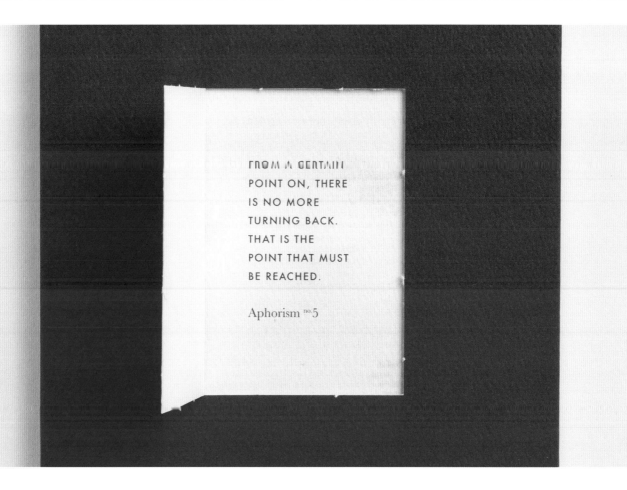

The secret, revealed.

All the Marai titles are foil-stamped.

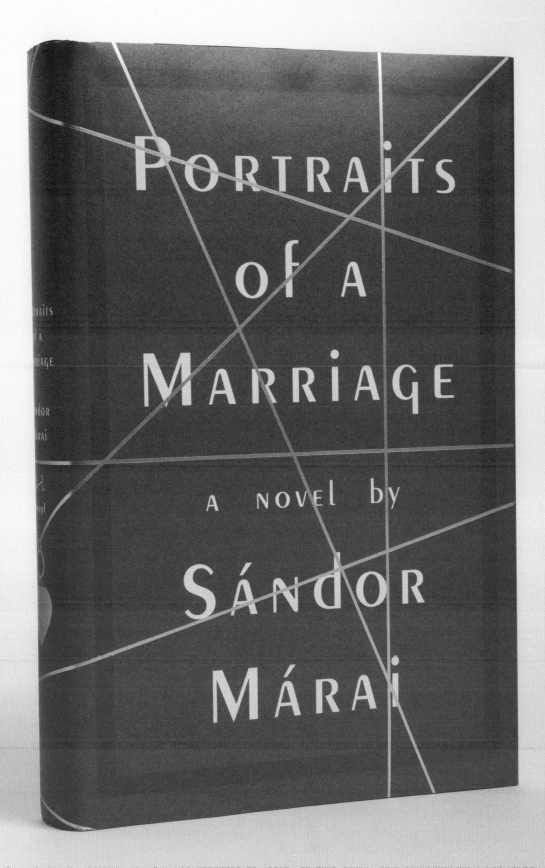

"It's Peignot Girl, and you should know it..." I was unnerved to learn, ex post facto, that the typeface I had chosen here was the same typeface that graced the opening credits of THE MARY TYLER MOORE SHOW. (I have had no typography training.) However, after a little research, I subsequently learned that this face, Peignot, had actually been cut by A. M. Cassandre in 1937. Phew!

Marguerite

Duras

The

Lover

A Novel

Angel or devil? I opted for the cover on the right. Ultimately, I felt that this cover AT LEFT was too self-consciously designed.

"Very early in my life…

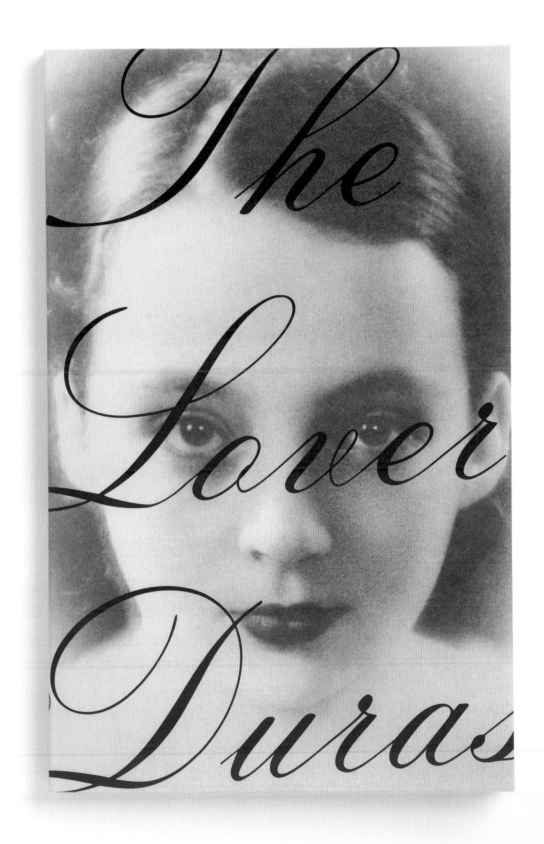

it was too late." —M. Duras

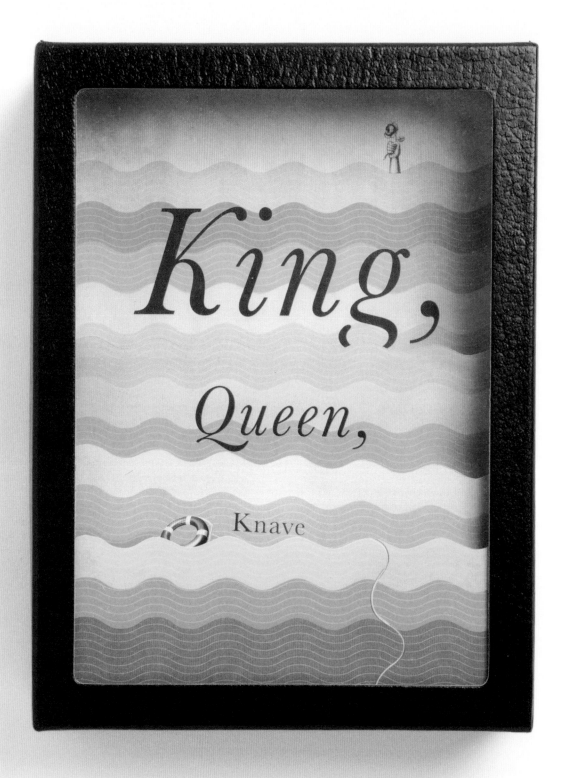

A paper construction inside of a specimen box. This was then photographed to become the cover for Nabokov's book, included as part of John Gall's Nabokov backlist series.

One of my many (purely hypothetical) LOLITA covers, and my favorite of the ones I've made.

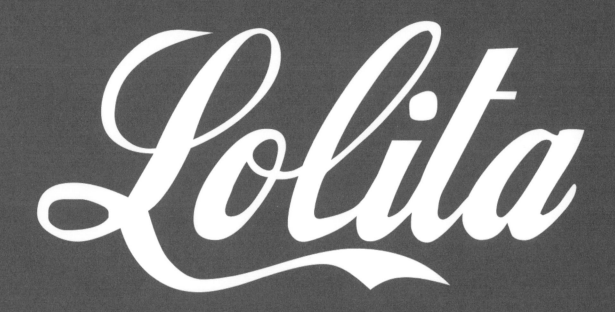

"We had breakfast in the township of Soda, pop. 1001."

Covering *Lolita*

"*Lolita* was discussed by the papers from every possible point of view except one: that of its beauty and pathos." —Véra Nabokov

"Be an active trader between languages. Carry precious metals from one to the other." —Vladimir Nabokov

I was recently asked to judge a book cover competition. I've judged several of these over the years, but this contest was rather unique; it comprised unpublished covers commissioned expressly for the jury to ponder, rather than titles already commercially sold. Looking over all of the entries, I found myself repeatedly coming back to one particular contestant's book cover, dwelling obsessively on it. The cover in question was a proposed jacket for Nabokov's *Lolita*.[1] It was very simple. The majority of the cover was negative space; the title and author's name was crudely handwritten around an (artfully) artless painted pair of lips.[2] The whole composition strongly hinted at an underdeveloped and mythologized understanding of romance—it was neither lusting nor leering, nor overly proud of its own wit;[3] it seemed to eschew the urbane gaze of Nabokov's old-world narrator in favor of a naive and guileless one—which is to say that this was an artwork, I imagined, that a young Dolores Haze might have made.[4]

I'm sure the effect is unintentional. And yet, the naiveté suggested by the cover reminded me that the unequal object of Humbert Humbert's attentions is a child. And this line of thinking, in turn, reminded me that *Lolita* is, and should continue to be treated (despite its verbal gymnastics, lasciviousness, and intermittent humor) as a shocking and sad book (Dolores, or *sorrows*). It is not a sexy book; not an *erotic* book.

It is easy to forget; especially easy given all of the soft-core *Lolita* renderings (book jackets, film adaptations) we've seen down the years. Nabokov's is a tale of perversion—unequal partnership, corrupted youth, and non-consent. *Lolita* is, for sure, a tragi*comedy*, and there are elements of the glib, the sensual, and the pure slapstick in it—but these days we tend to overemphasize these easy aspects of the tale and its telling. Furthermore, we think on the various rejections and bans, and the generally shocked reception the book was given upon publication, and we mentally admonish our predecessors for their prudishness. We then make book jackets and other portrayals that are self-congratulatory in their sensuality or lack of gravitas. But are these representations of *Lolita* truly speaking on behalf of the book or, rather, some modern attitude toward mid-century mores? The more I

1 Directly after I judged this competition, I was asked to contribute my own *Lolita* cover(s), as well as this essay, to John Bertram's book *Lolita: The Story of a Cover Girl*, 2013.

2 The cover was made by designer Emmanuel Polanco.

3 These days, book jackets often revel overtly in wit, conceptual deviousness, and unusual clever or droll juxtapositions. We as a professional community seem to have elevated the visual bon mot above all other virtues. Not that wit in itself isn't valuable and doesn't deserve an appropriate place in design, but wit is not the same thing as *insightfulness*, and often insightfulness is what is called for in a book jacket. The fetishizing of cleverness by the book designers has taken a toll, I believe, in that quite often these clever solutions work at cross-purposes to the (more often than not sincere) narratives they represent. A book whose author has gone out on a considerable limb in order to write in a genuine and unaffected fashion does not want a cover that winks at the reader. Wit, when it becomes compulsive (as anyone who has a friend who puns too often knows), quickly becomes its opposite—dullness or predictability. Are we designers, as a group, *that punning guy*? I hope not.

4 *Lolita* certainly does not come across as *guileless* in V.N.'s novel. But of course: she wouldn't, would she. We only see her through H.H.'s distorted lens.

think on it, the more I feel like this kind of jacketing solution for *Lolita* is false and pernicious in its own way. It is at best a misrepresentation, at worst a kind of whitewashing, and it does no justice to the text it putatively represents.[5]

There seemed to be nothing to prevent my muscular thumb from reaching the hot hollow of her groin-just as you might tickle and caress a giggling child.

Ick. It's repulsive. But it is wonderfully alliterative. But still: ick. This is a child we are talking about here. Explicitly.

This dialectic is partly the point. If one examines the one sex scene we are privy to in full, this infamous *lap scene,* what is salient is that only one member of the couple is fully aware that a sexual act is transpiring. Lolita wiggles, squirms on her (soon-to-be) stepfather's lap, and he achieves "the last throb of the longest ecstasy man or monster had ever known."

(Double ick.)

It is the discordant lopsidedness of the encounter, in age as in awareness (coupled with the dual resonance of the lap as both the safe seat of childhood—the place where trust is implicit—and the intersection of sexual congress) that makes the scene rich, if still repugnant. This friction incriminates the reader, who is also, for reading

the passage, in collusion, and now, like H.H., a "monster." This incrimination, I would posit, is partly the point. We are complicit, we readers of Nabokov's *Lolita*. We are witnesses to a crime, moreover witnesses who are seduced *by* the crime, by its trappings, by the cadence of its sentences, by Nabokov's genius, and we just can't turn away.

Pretty depictions of softly lit Lolitas (anatomized or whole) on book covers seem to perform the opposite function: they downgrade our outrage and our complicity (and in so doing they also lessen the effect of the book's central metaphor). They are the cover-design analogue of porn stars in schoolgirl uniforms—there is no longer anything obviously discordant about them, as they are the fantasy fulfillment of a culture that has long since sexualized its young. We don't see those plaid skirts and feel the frisson of an unusual juxtaposition. We see merely the vague promise of sex, if even that. The uniform in this case is just another symbol that has lost its original immediacy. And through repeated use it has become meaningless. It no longer represents innocence; thus it cannot represent *fallen* innocence either.

So what's a designer to do?[6] Does a designer attempt a (truly) shocking cover, in order to properly represent the ethical disquiet that Nabokov's narrative provokes?

She was shaking from head to toe (from fever)
She complained of a painful stiffness...and I

5 Christopher Hitchens, describing his (and my own) mutating relationship with the narrative: "When I first read this novel, I had not experienced having a twelve-year-old daughter...I dare say I chortled, in an outraged sort of way, when I first read, 'How sweet it was to bring that coffee to her, and then deny it until she had done her morning duty.' But this latest time I found myself almost congealed with shock." Hitchens also judiciously reminds us that "immediately following each and every one of the hundreds of subsequent rapes the little girl weeps." Read that sentence again. Now survey again the various visual treatments this book has been given.

thought of poliomyelitis as any American parent would. Giving up all hope of intercourse...

Groan.

In surveying the extant editions, I don't see many that rise to the challenge. Perhaps only the first edition had it right: the so-straight-it-must-contain-something-dangerous approach, otherwise known as the "brown paper wrapper gambit," (which in the case of *Lolita*'s first edition, was green.) But perhaps it's simply impossible to give this book the jacket it deserves, if one believes it deserves a representation of the central sexual relationship between a young girl and an older man.

But as it turns out, this book is not actually about[7] a deranged pervert lusting after a nymphet.

I mean, *it is,* but it is clearly much more than merely this. *Lolita*'s central argument concerns the young and the old, but the old *world* and the new *world*. As most of you know, *Lolita* is a book which contends with the idea of *America:* a young, robust, bobby-socked, dewy-eyed, and apple-cheeked America, an America of "[s]weet hot jazz, square dancing, gooey fudge sundaes, musicals, movie magazines and so forth." This is an America of license plates, motel room keys, coke bottles, chewing gum—a young, fresh, insolent, unaware America.

Lolita is the tale of a gentleman caller, hailing from an exhausted continent as exhausted in its linguistics as it is in its literature, to adopt, as H.H. adopts his ward, a new language—to inhabit it, fetishize it, tyrannize it.[8] Nabokov's is a book about America and its language. Isn't it?

--

Every book (or, rather, every good book) contends with a calculus greater than the mere facts of its narrative. If books were only drama-delivery systems, we'd have nothing to talk about in literature classes and Stephen King would be a Nobel Laureate.[9] The facts of the narrative may keep us turning the pages, but it's a book's greater purpose, as it were, that makes it truly worthy of our attentions. We come for the literal, but we stay for the literary.

This much is obvious, but it raises an important question for designers of book jackets. We book-jacket designers are delegated the responsibility of representing a text—that is, unless we see ourselves as meager decorators of it. But assuming for the moment that we've taken on the task of representing the text rather than just adorning it, must we designers determine what a book is *about* before we design a jacket for it? When

6 It should be mentioned that book designers are only *partially* responsible for the covers they produce, in the sense that their work has to pass muster with a marketing department as well as an editorial division (not to mention authors, spouses of authors, agents, et al., all of whom must be appeased). It bears repeating that in attempting to *sell* a book, designers must, not always, but sometimes, pander to the very public I was just dressing down—a public that on occasion lacks the interpretive subtlety to parse literary subtext. That is to say, if the general reading public expects a schoolgirl or schoolgirl uniform on a *Lolita* jacket, then book buyers and book sellers will also be expecting a schoolgirl or schoolgirl uniform on a *Lolita* jacket; and one can then reasonably assume marketing departments in publishing houses will want them as well. In the end, going upriver towards its source, even editors begin to take their cues from misinformed readers at large. I will reveal that on one occasion, a good friend who is a multiple best-selling author was told by his editor that his latest work wasn't up to snuff because it "didn't seem enough like the kind of thing" he writes. In other words, on occasion, even authors cannot beat back the tide of their own marketing expectations. (Dead authors have no say in this process, which is one reason we designers love them as much as we do.) In any case, managing these expectations is, sadly, also part of our jobs as jacket designers.

7 I am aware that "about" is a tricky word. More on this soon.

8 "Even *Lolita*, especially *Lolita*, is a study in tyranny." —Martin Amis, *Koba the Dread*

9 For the record, I am a big fan—just not for the same reasons that I am a fan of, say, James Joyce.

I'm reading a manuscript, I find I'm constantly on the lookout for images, characters, ideas that can serve, metaphorically, as proxies for the whole. But the question is constantly emerging in my mind: *Is this "whole" the narrative itself, in its literal details, or the thing(s) the narrative is driving toward—its greater underlying significance?*[10] Which is to say: is it our job in the case of *Lolita* to represent "the central sexual relationship between a young girl and an older man"? Or are we being asked to delve deeper? I would argue for the latter.[11] After all, how impoverished would our book-design jobs be if we didn't, as a rule, delve deeper? If we didn't *interpret?* If we didn't visually translate that which is most essential in a book?

Our jobs would be sad indeed. And our jackets would be too.

Lolita, and all the rest of our covered texts, would be ill-served.

PM

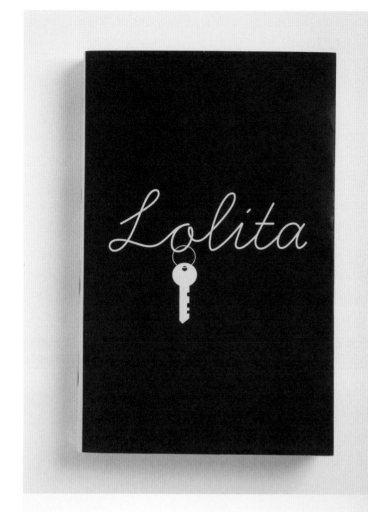

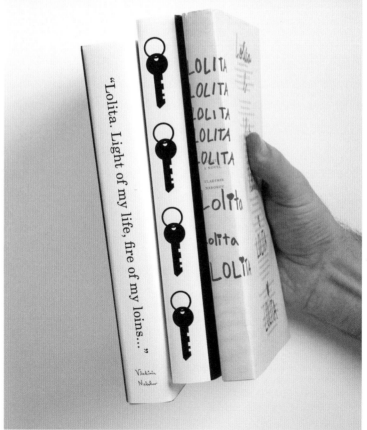

10 ABOUT-NESS:
It is extremely complicated to explain what one means when one says that a book is "about" something or other (difficult because the word "about" is hard to define; difficult in the sense that most good books proffer more than one central argument; and difficult, *especially* difficult, in the wake of the putative "death of the author," Barthes, Saussure, Derrida, pluralities of meaning, intertextuality, etc.) As Tom McCarthy puts it in the introduction to this very book: "We have (thankfully) jettisoned our belief in authorial intent, alongside any notion that a text might have an underlying, base 'meaning.'" And yet...what I call "the cover-design test" would be useful in literary critical discourse: i.e., if your theory of meaning (Marxist, post-structuralist, feminist, Freudian, postcolonialist) cannot translate into a commercially viable book cover, then it fails at properly representing your text. All of which is to say that I believe there is more consensus around what books are "about" than most may think. We designers, in our jackets, attempt to capture meaning that is not exactly consensus-driven, but rather that is both true enough, and flexible enough, that most readers won't find it a stretch to believe it. That is to say, we are trying to maximize understanding. In this sense, jacket design is a kind of interpretational utilitarianism.
11 Ultimately, this question, the question of what it is we designers ought be doing on behalf of the reader, the author, the entire publishing endeavor...is too complex to unpack here.

✕

lo.
lee.
ta.

Vladimir Nabokov

Reading in the Digital Age, or: Aphorisms for a Future Book

* Who speaks for the static? Who speaks for the immutable? Who speaks for the bounded; the fixed? The delimited?

* Will the future book have feature bloat?

* The intimate (private) aspects of reading are a feature. This aspect of reading does not need improvement.

* Reason to love a book 1: it isn't part of a network.

* Reason to love a book 2: it is a closed system.

* People do not always relish agency.

* A multitude of diverse media already provide agency for consumers of narrative.

* Sharing makes thought performative.

* Sometimes, the fact of a single book in multiple platforms forces us into an unwanted awareness of platform.

* The reading medium should be immersive, by which I mean transparent. This is best accomplished by its being boring.

* The conviction that digital will transform reading, implicitly for the better, is an easy belief to cleave to.

* If the spread of Christianity was successful, in part, due to the advent of the codex, and if the Reformation's influence was enhanced by the rise of the pamphlet; and if Renaissance humanism and the great works of the Enlightenment were abetted by moveable type and the book; then what is the glorious school of thought taking greatest advantage of the digital revolution? Techno-determinism? Techno-evolutionism? In other words, is the philosophy poised for ascendancy and hegemony due to the new means of transmission, an unwavering belief in, and enthusiasm for, the ascendency and hegemony of the new means of transmission? The conviction that the printed book, mass-made and widely distributed, would change the world, would not have constituted, by itself, an intellectual revolution.

* One medium does not replace another medium. (Obs)

* The salient attributes of a reading format may be determined by where and how that reading format is sold.

* The format discussion is being monopolized by two opposing species of fetishists

* In paying for a book, I feel as though I have paid for the right to read its text however I'd like to.

* Books need faces.

* A digital book cannot be yours in any lasting respect. Nor will a digital book ever feel like a gift.

* What other activities you perform (other than reading) on a platform or device determines the flavor of that reading experience. (What else is mediated by screens?)

* The limitation of storage space for the physical book is an unacknowledged boon to readers. It keeps one's knowledge and experience in sight, and at hand. (There is such a thing as too much material.)

* How many (cultural) conversations is too many (cultural) conversations?

* The paradigm of physical bookselling is limited selection; curation. The paradigm of digital bookselling is abundance. These paradigms are incompatible.

* Consider the book when considering the format. (Not every book wants to be a gesamkunstwerk.)

* The smell of old books is mildew.

* The walk to the dictionary served a purpose.

* A very sophisticated form of haptic feedback is already offered by physical books.

* Imagine a new paradigm wherein our children mock our unwavering belief in, and devotion to: ease, portability, and speed.

* What if our technology threw up barriers? What if technology added drag; slowed us down? Promoted friction?

* It may be said about the future book that: it will be formulated—to a greater extent than we imagine—without our conscious intervention. It will not be conceived and constructed by a modern Gutenburg, but, rather, by a coalescence of accidental forces—economic weather patterns; technological developments; cultural fads; an array of overlapping and contradictory desires both institutional and personal. Perhaps this is the best thing that may be said about the future book? That it won't be designed.

DANTE
THE DIVINE COMEDY

A proposal for a public domain backlist, which would be sold bundled — as both physical books, and digital ebooks.

VERNE
20,000 LEAGUES UNDER THE SEA

HOMER
THE ILIAD

CERVANTES
DON QUIXOTE

STOKER
DRACULA

OVID
METAMORPHOSIS

THE CALL OF THE WILD
JACK LONDON

THE ART OF WAR
SUN TZU

PLATO
SYMPOSIUM

THOREAU
WALDEN

WELLS
THE TIME MACHINE

MACHIAVELLI
THE PRINCE

MELVILLE
MOBY DICK

BEOWULF

DICKENS
A TALE OF TWO CITIES

WILDE
THE PICTURE OF DORIAN GREY

CONRAD
HEART OF DARKNESS

THE WIZARD OF OZ
L. FRANK BAUM

NIETZSCHE
BEYOND GOOD AND EVIL

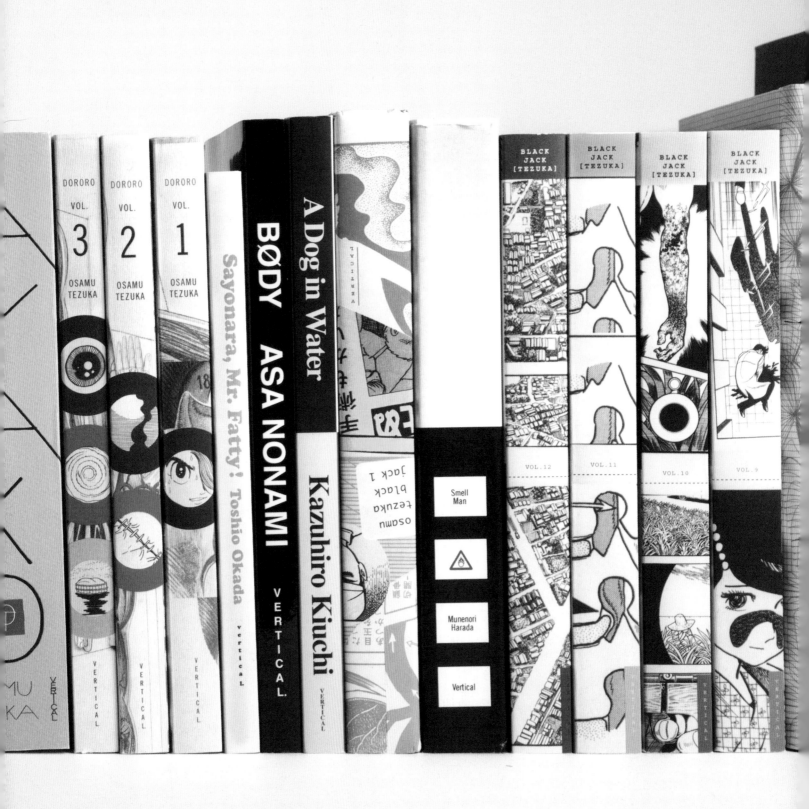

Vertical

"Manga is sentiment. Manga is resistance. Manga is bizarre. Manga is pathos. Manga is destruction. Manga is arrogance. Manga is love. Manga is kitsch."
—O. Tezuka

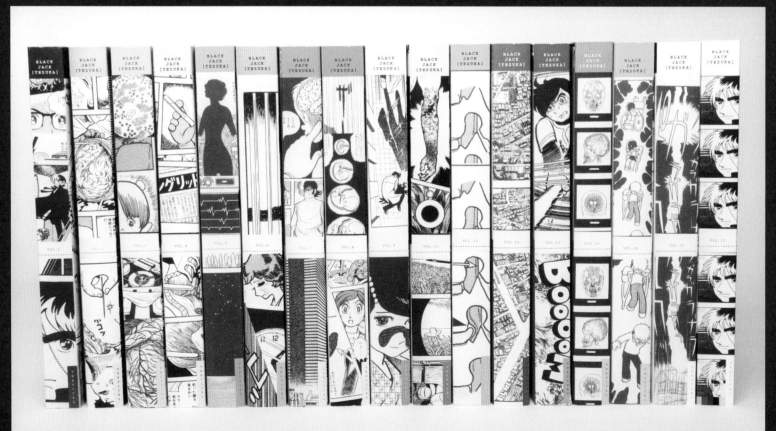

Black

Jack

Osamu

Tezuka

VOLUME NO. 4

Vertical Press is an independent Japanese book publisher, for whom I work in a freelance capacity.

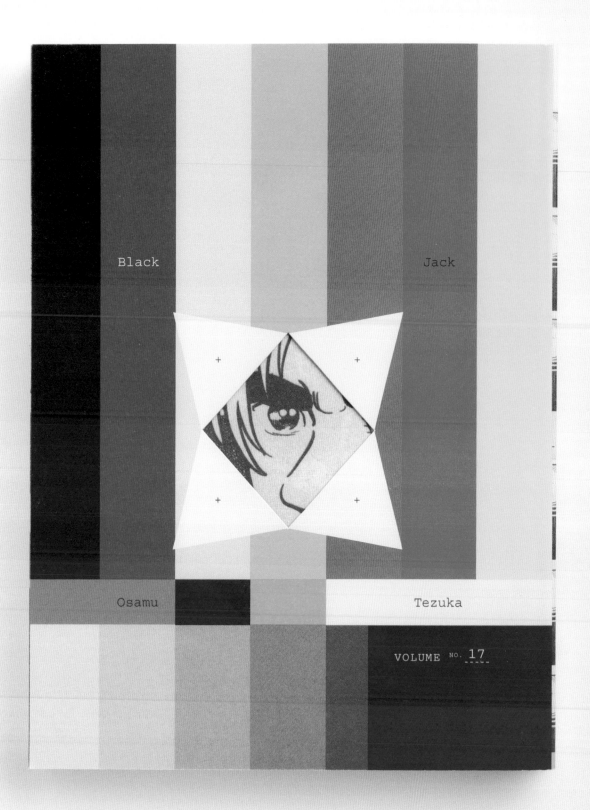

Black Jack

Osamu Tezuka

VOLUME ᴺᴼ· 17

The largest series by a single author I've ever worked on. All told, BLACK JACK ranged over
seventeen books. This series was, for me, above all else, a meditation on color.

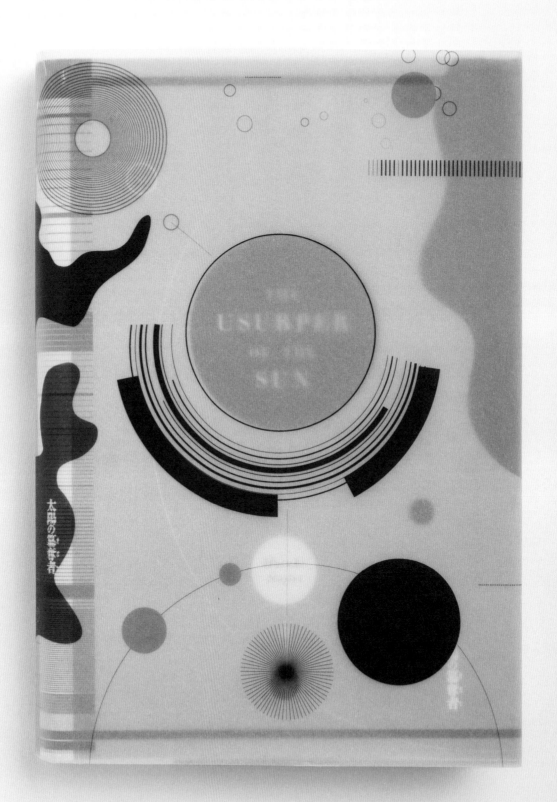

Vellum jacket over pre-printed case. Still waiting for this one to be on shelves...

THE
USURPER
OF THE
SUN

Hosuke
Nojiri

太陽の簒奪者

7 Billion Needles | Nobuaki Tadano

Volume 2

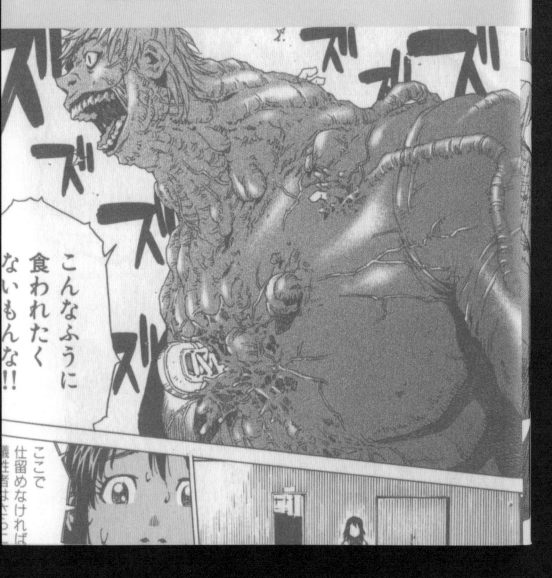

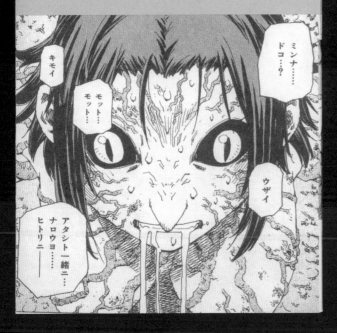

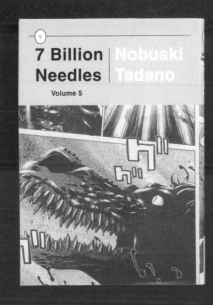

A series of manga covers based loosely on the old Penguin format. The old "type in a box at the top" trick.

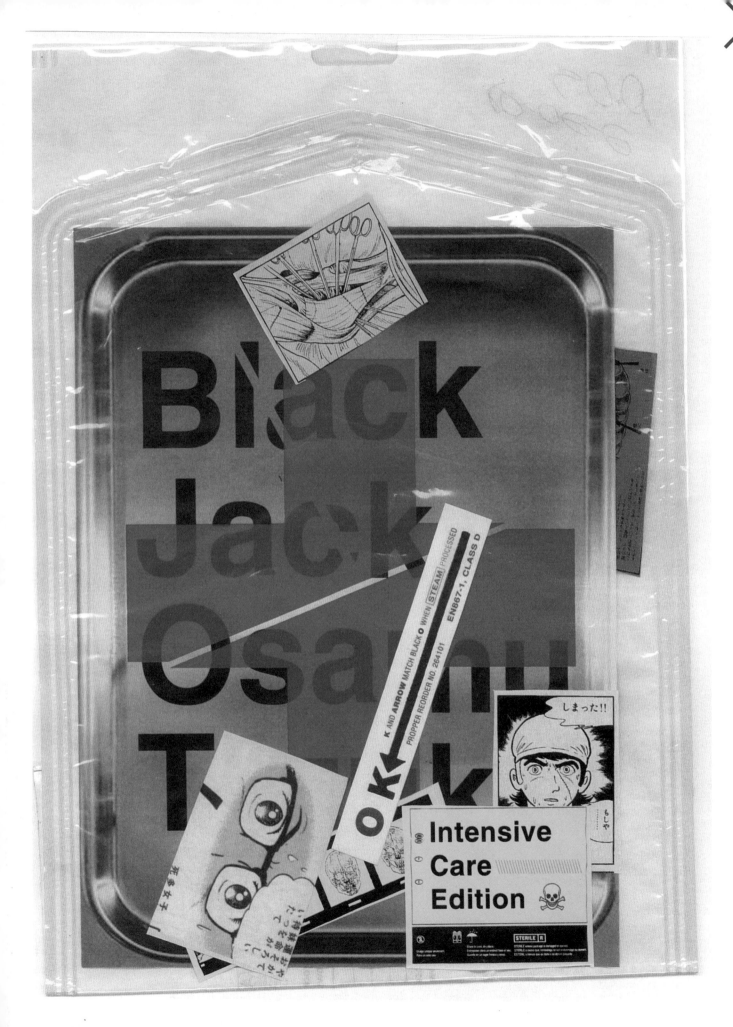

by **Toshio Okada**

A Geek's
Diet Memoir

Sayonara, Mr. Fatty!

My first, and last, diet book cover.

Nintendo Magic

OSAMU
INOUE

The only book I've ever designed
that includes a parental warning.

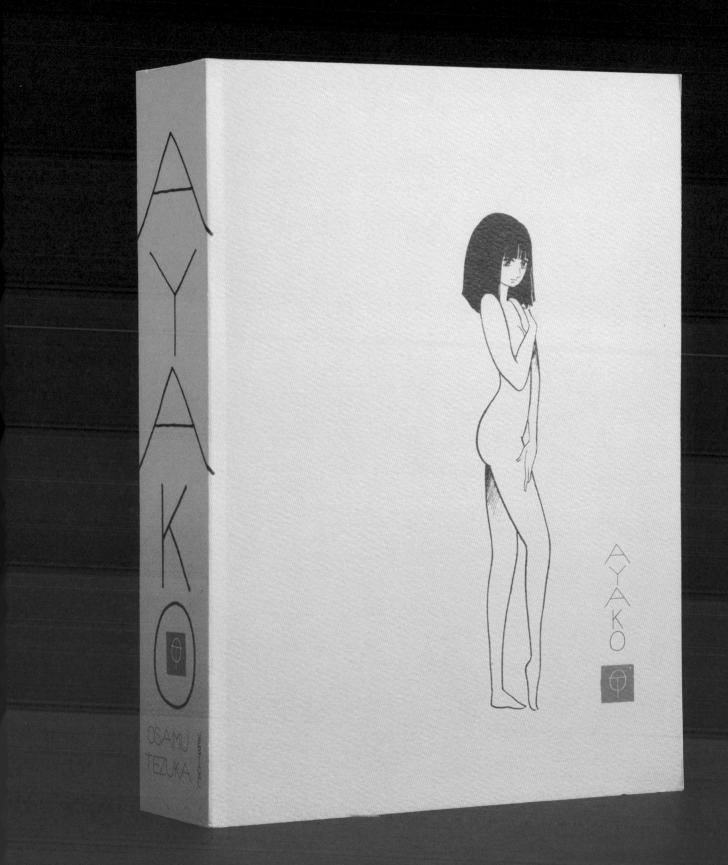

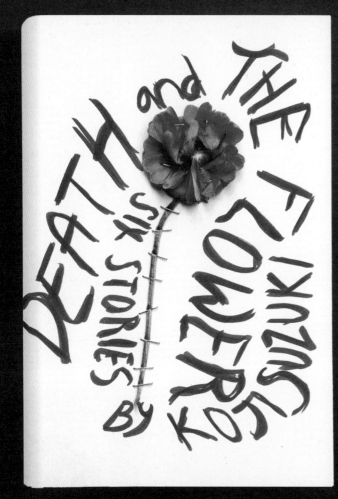

Death and the Flower

Six Stories by Koji Suzuki

Author of The Ring Trilogy and the Winner of the 2012 Shirley Jackson Award for Edge

Translated by Maya Robinson and Camellia Nieh

Two books by the author of the J-horror classic, RING.

EDGE

A NOVEL

KOJI SUZUKI

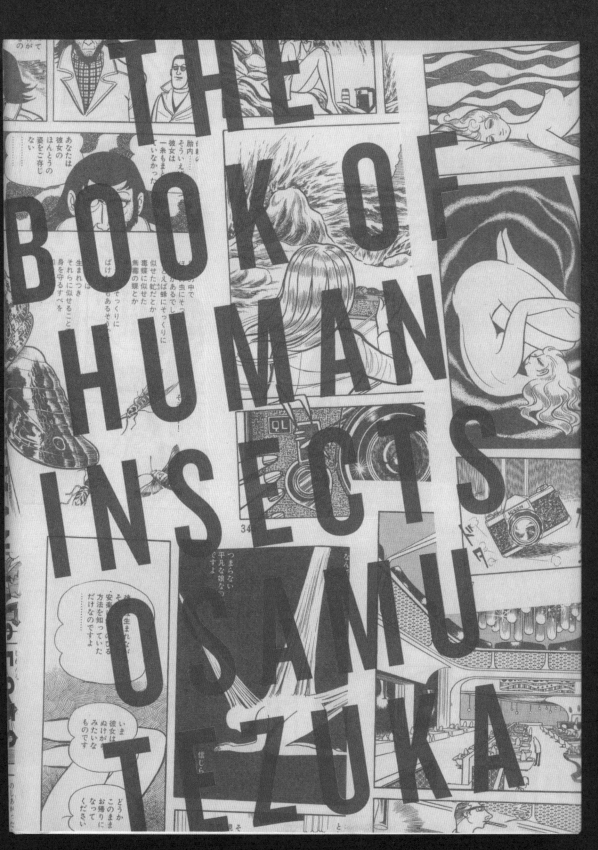

Smell Man // Munenori Harada

Message to Adolf

Part 2. by Osamu Tezuka

Vertical

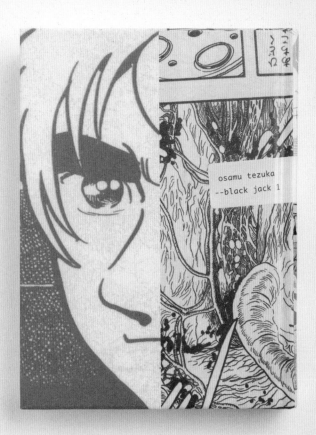

osamu tezuka
--black jack 1

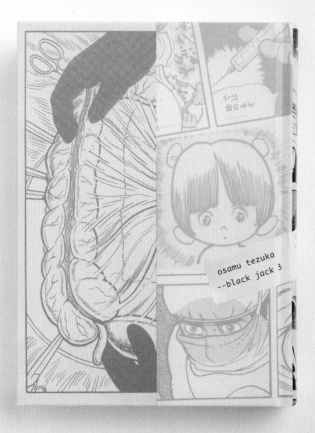

osamu tezuka
--black jack 3

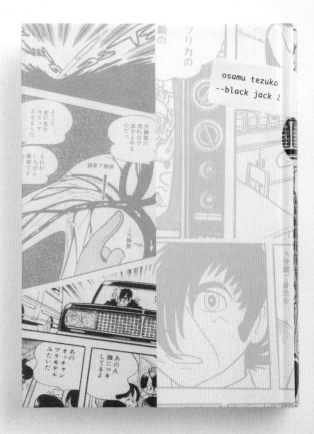

osamu tezuka
--black jack 2

Kazuhiro Kiuchi

A Dog

in

Water

Literary Fiction

It took me too long to realize that writers should not be allowed to interfere when it comes to the design of their book jackets.

There is something horrible about that moment when one's imagination for how spectacular the jacket *might* be, is spoiled by the reality of what it finally is. When the text is done and the jacket doesn't yet exist, it is too easy to want the jacket to accomplish what the text, without yet being read, cannot—it should entice and amaze and seduce book buyers, and it should costume not just the book, but the writer, in the most spectacular textures and tones. This is just to say that I am subject to the most irrational, impossible desires when I write a book and it has not yet been jacketed. The missing jacket is the final piece by which nearly everyone will come to know the book. The writer wants the jacket to stand up for the book, serve as the most perfect flag. The jacket should celebrate the strengths of the book and conceal its flaws. It should perhaps rouse dormant chemicals in the body and cause a kind of sharp lust in the buyer, that might only be satisfied by actually eating the book. In other words, the writer wants something from the jacket, in the most desperate way, that it can never accomplish. Unless, maybe, the jacket was designed by Peter Mendelsund.

Peter's designs for *The Flame Alphabet* and

Leaving the Sea are striking, primal, and gorgeous. I think of them as wishful covers. As in, I wish my books were good enough to deserve these jackets. They have a feeling of inevitability. I'd followed Peter's work on and off before finishing *The Flame Alphabet*, but it wasn't until I saw his iconic Kafka jackets, for the paperback reprints published by Pantheon, that I knew how brilliant he was. These are vibrant, colorful, glee-smeared book covers for one of the bleakest writers in history. It seems so obvious now to design jackets that reflect the unsettling comedy in Kafka's dark narratives. I still laugh uneasily when I look at them, as I laugh uneasily when I read Kafka.

When I first spoke with Peter, after he'd begun work on the jacket for *The Flame Alphabet*, I was struck by how carefully he'd read the book. He fucking seemed to have *studied* it. This is the kind of close reading one longs for from an editor. To have it from a designer is unnerving and, of course, a piece of very good luck. When he asked me if there was anything I had in mind for the jacket, I knew by that point that I did not want to get in his way or even to put my voice in his head. I figured he'd have enough people to answer to

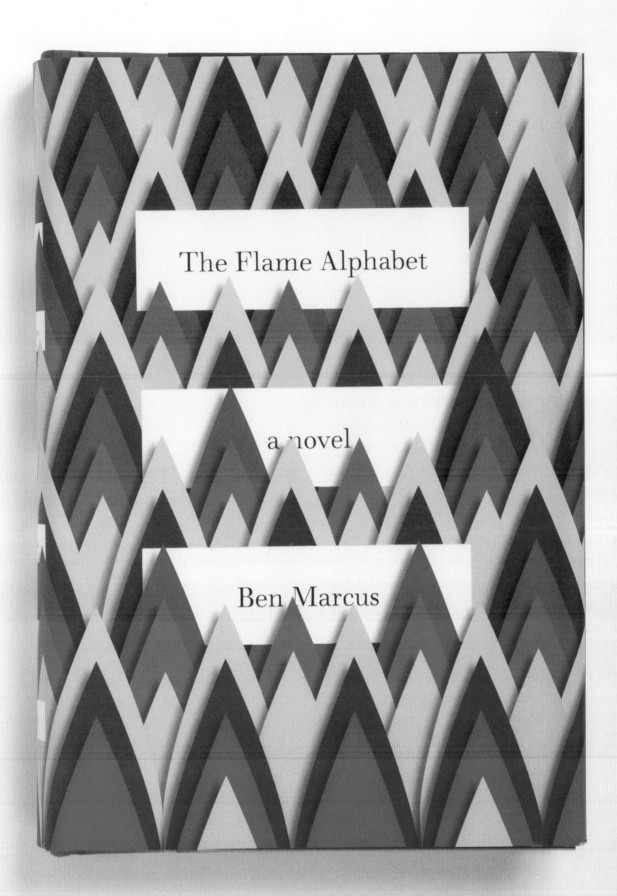

in marketing. I'm not a designer and I didn't trust my own ideas. I wanted an original Mendelsund, and I think I just said I'd prefer a cover without burning letters, which would seem to be the obvious bad design choice the title was just begging for (and would get, with one of its foreign editions). This was the extent of my directive.

Which makes it kind of funny that Peter did end up designing fire for the jacket, although he seems to have done it by accident. As he tells it, he was cutting up paper to make birds, which figure in the novel, and when he flipped his design over, he discovered fire. This seems to perfectly illustrate the complex, thoughtful routes he takes in order to achieve sublimely simple and beautiful designs. When I first saw the cover it was a revelation to realize that it could be unburdened from saying very much at all about the book—it could simply be stunning to look at, and people would want to pick it up. Which is the point. But over time I've come to see that the cover really does, to me anyway, say a lot about the book, and it shows me, the more I look at it, that Peter didn't really do anything by accident at all. The same is true for his jacket for *Leaving the Sea*. It is sumptuous, playful, and gorgeous to look at. I have yet to hold it in my hands. It is so far a color Xerox and a JPEG, but even so I feel just damn lucky to be costumed by such a tremendously gifted designer. Peter Mendelsund is a true artist.

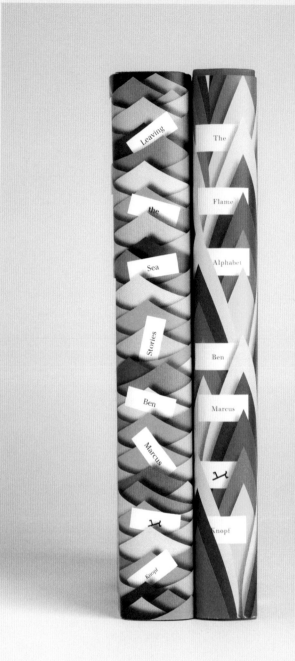

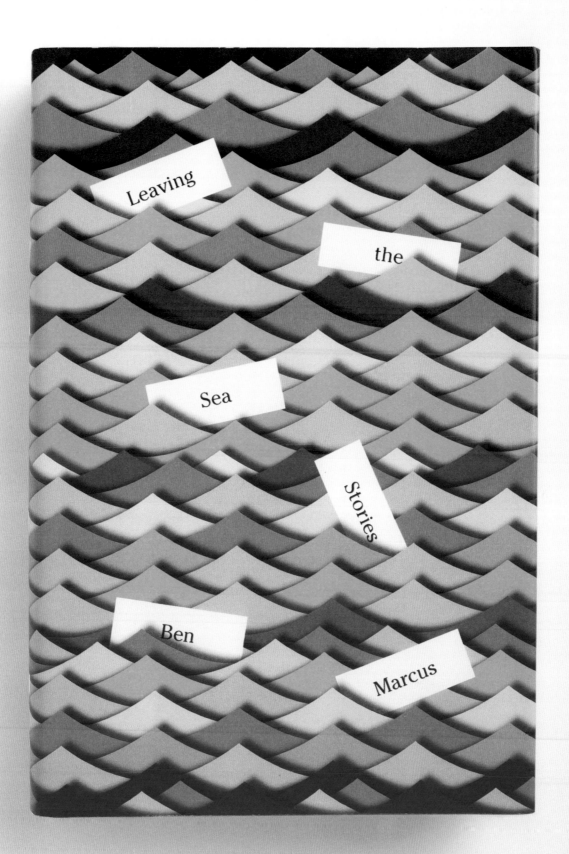

FROST

THOMAS BERNHARD

A NOVEL

The red-top tabloid as a metaphor for the current state of England.

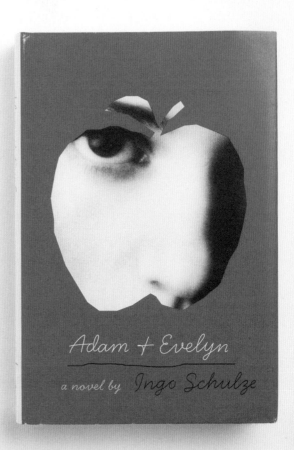

The Man with the Compound Eyes a novel
Wu Ming-Yi

Taiwanese ecological science fiction.

"There came a lull in the fighting, and the deafening barrage slowly abated to the sporadic popping he associated with picket skirmishes. He thought it dusk now, but a dusk like none other, a failure of light that lacked the promise of darkness…"
— D. McFarland

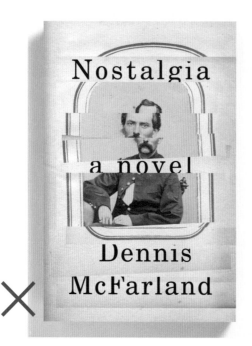

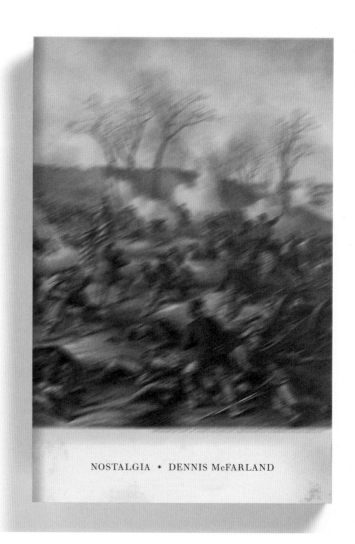

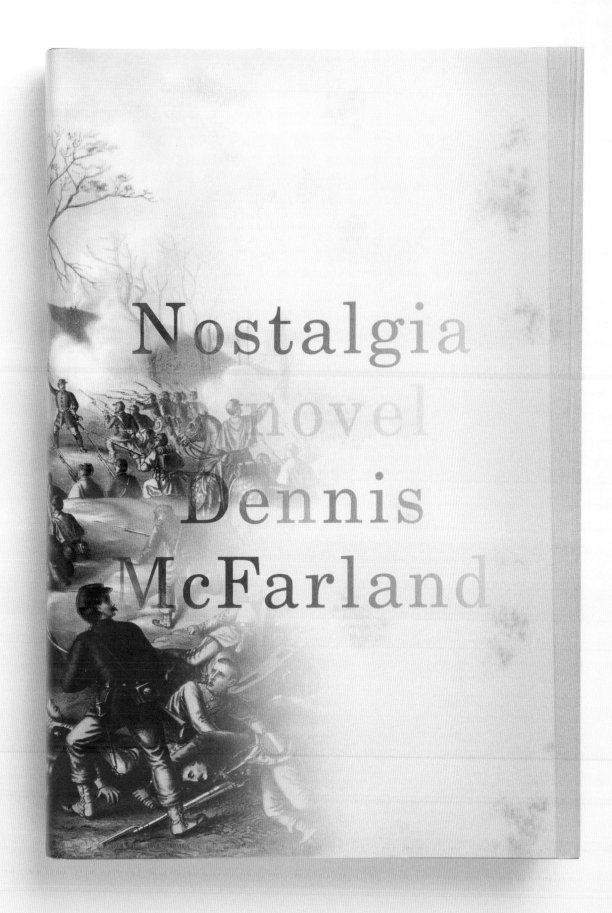

Nostalgia

a novel

Dennis McFarland

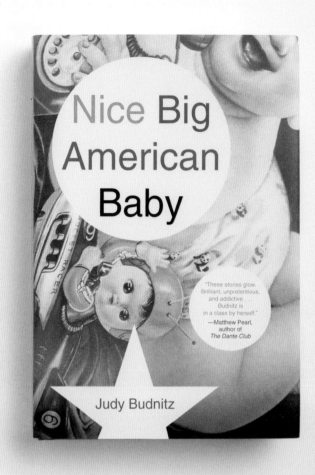

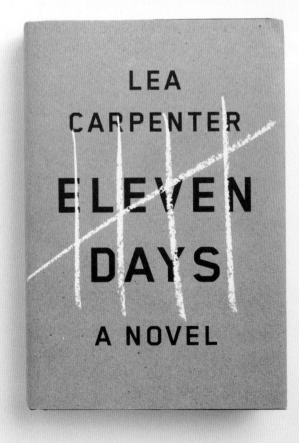

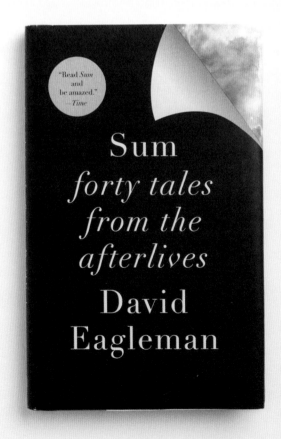

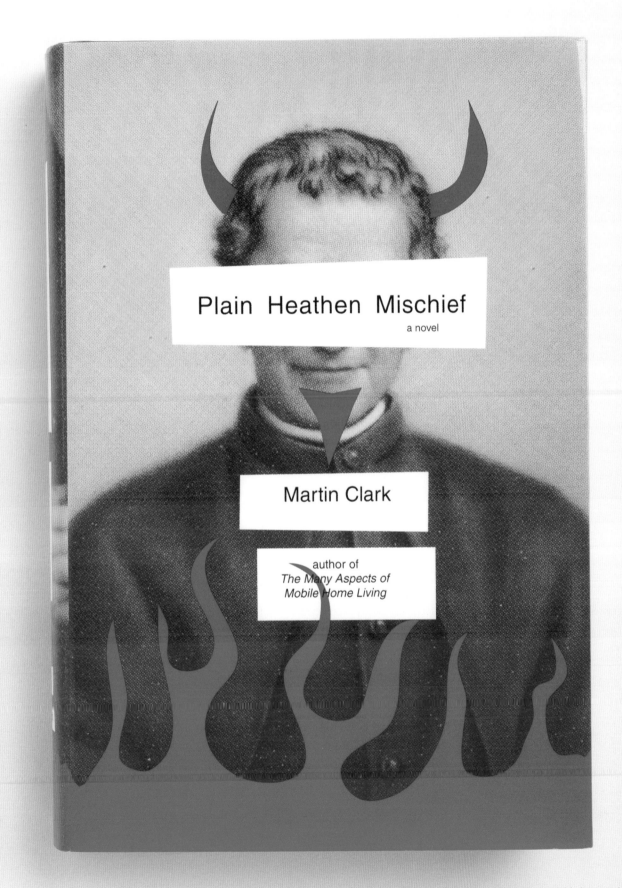

Plain Heathen Mischief

a novel

Martin Clark

author of
*The Many Aspects of
Mobile Home Living*

Martin Clark's tale is a modern recasting of the Job story. I wanted to portray the main character's religious crisis in such a way as to suggest the meddling of an outside agent (in this case the devil rather than God). As a side note: the Salesians, the followers of Don Bosco, whose image is seen here, took umbrage with my depiction of their spiritual leader. In my defense, this book is, if irreverent, deeply religious.

IMRE KERTÉSZ

WINNER OF THE NOBEL PRIZE

"Not since Kafka or Beckett . . . has a writer packed so
much metaphysics into so tight a space."
—*The New York Times Book Review*

LIQUIDATION

A NOVEL

"Man, when reduced to nothing, or in other words a survivor,

WINNER OF THE NOBEL PRIZE

IMRE KERTÉSZ

DETECTIVE STORY

A NOVEL

"Appealingly meditative. . . . A compelling story, with a clever twist. . . .
Kertész writes with characteristic lucidity, grace, and grim-gay humor."
—THE PHILADELPHIA INQUIRER

is not tragic but comic, because he has no fate." —I. Kertész

By Alexander Maksik

At first the books are shapes, side by side on shelves, and piled on tables.

At first the books are shapes, side by side on shelves, and piled on tables. They are objects decorated with what I will soon learn are letters, words, and names. I use some of them as bricks for building. I make houses and forts and castles. Before I can read, I memorize the spines the way I memorize the smooth wooden saltshaker, the pepper mill, the candleholders, the rugs, the fabric of the couches, the surface of the kitchen floor, the landscape of my childhood. Before I read, I know Nabokov. Tolstoy. Pnin. *Crime and Punishment. Shōgun.* P.D. James. *Anna Karenina.* Images as solid and as permanent as the walls, the lamps, and the tables. Long before I know what the bricks are really for, I learn that they are sacred. And they are everywhere: at the beach, at our bedsides, in my father's briefcase, in my mother's purse, in the car.

Later, gradually, I begin to understand the correlation between the bricks and what they are composed of—paper, ink, glue, string, letters, words, sentences, punctuation, paragraphs, characters, stories, endless, endless mysteries, questions, problems and failures and triumphs beyond my imagination. But first, I loved the things themselves.

And as with all things I love, I want somehow to possess them. For many years, it is the reading that provides a sense of possession, a feeling of membership. I, like my parents, begin to collect the books, arrange them neatly on my own shelves. By reading and reading and reading, I have become a member of an important club.

We go to bookshops—those calm and sacred places that house the sacred objects, and I begin to feel it is not enough to read. I want to create one of those things myself. I look at the M section and with a thumb and forefinger spread the books apart just to make a little space between Mailer and Malamud. It isn't so much a desire to write, as it is to belong, to participate in this thing I barely understand. All of those covers, all of those colors, fonts, textures, the good ones so mysterious, behaving like the good stories themselves, like all good things really, posing so many questions, and offering so few answers.

A great many years pass between the time I understand that I want to see my name running along the spine of a book and the time that I do. I sit at my kitchen table and open the envelope and withdraw my own novel. It is my second, but the thrill is the same. No, it is greater. I hold the thing in my hands, feel its texture. I am reminded of why I write. It is as close to permanence as I can come. I know few things more satisfying, more beautiful, and more fundamentally connected to my youth than a well-made book, and so to see my own here, sheathed in Peter Mendelsund's cover, is thrilling. It is an object

arrestingly beautiful on its own, yet inspired and informed by the story I've written, by the characters I have imagined. It is a powerful alchemy. To see this thing, to hold it in my hands, to possess it, moves me beyond language. Peter's cover is like the novel's score. What magic this is. What childlike joy I feel.

Once I was a boy building castles out of books. I fell in love not with the castles, but with the bricks. I came to dream that I would one day write a book myself. And now so many years later, in a small bookshop in New York, here is my novel, wrapped in Peter's jacket, pressed against Nabokov's *Ada*, the same great brick of a book I'd used as a cornerstone of those forts and houses.

I would like one day to show my child the books I have written, to show her that whatever my failures, I have made these things and they are in libraries and bookshops. I will tell her that, when I was writing them, they were more important to me than anything else in the world. I will slide *A Marker to Measure Drift* from the shelf and say, "Look at the beautiful thing this man named Peter Mendelsund made. Take it. Go build a castle."

"The more the mouse pursues this line of thought, the more it seems to him that the cat is a large, soft mouse."
—S. Millhauser

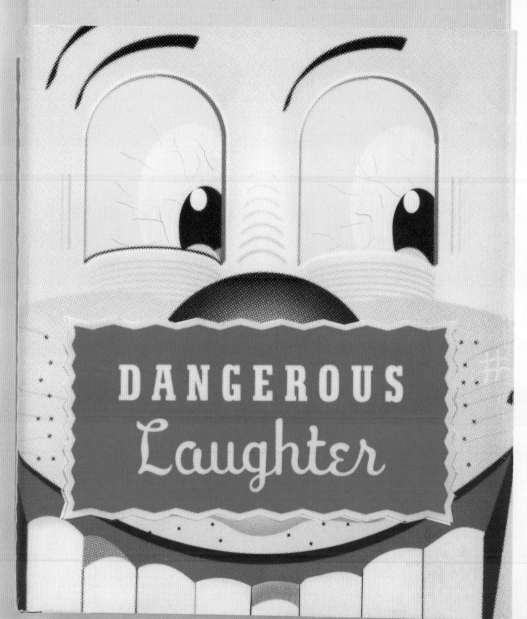

A three-quarter jacket in the "down" position, and...

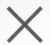

...in the "up" position. I always relish the occasions when I am afforded the time to illustrate my own jackets. Making the art myself, rather than commissioning it, is always my first inclination.

Steven

Millhauser

From the winner of the
PULITZER PRIZE

We Others

New &
Selected

Stories

What Is a Book Cover?

1. A Skin. A membrane. A safeguard. The book jacket protects the boards of a book from scuffing and sun damage. However, for most books (trade and mass market books), the jacket is no longer needed as a protective outer layer. These books' boards are cheap, durable, and undesigned (around the turn of the twentieth century, the decorative aspects of the book's covering transferred from the binding to the jacket itself.) If, for the majority of books, the jacket no longer serves a protective function in *fact*, it still shields the subcutaneous narrative *metaphorically.* As we spend more of our reading time in digital, disembodied, notional environments where texts lack differentiation, and may easily leach into one another unconstrained, covers (and physical books in general) remain part of an anxious cultural effort to corral and contain the boundless. The cover is a skin, here, in the sense that it provides a book with a unique *face*, and in so doing, it helps establish a text's unique identity. The cover thus, holds (in the sense of *constrains*) and *restricts*— as well as holds—(in the sense of tethers) the text.

2. A Frame. The text requires a *context*. A text also requires some kind of *preamble*; a throat clearing; an entryway; an antechamber. Jackets are the visual equivalent to the *foreword*, or to a front door. The jacket is a paratextual neutral ground between text and world. 3. A Reminder. A distinct jacket mapped to a distinct text helps index that text; identify and remind you of it. If you are looking for it, it is easier to find. If you need a mnemonic device for it, simply picture the jacket in your mind's eye.

4. A Souvenir; Talisman; Token. Reading takes place in another realm, in a nebulous, mental realm. The jacket is the souvenir we take back with us from these metaphysical travels. In this sense, the jacket is a snowglobe; a tee shirt; a commemorative key chain. 5. An Information Booth. The jacket tells you *what* the book is: what the title is; who the author is; what the book is about; what genre it may belong to. It will tell you who else read and enjoyed this book. The jacket is a grab bag of information: some primary, some subsidiary, some important, some annoyingly trivial. A jacket, like an information booth, will also locate you "geographically," if, like me, you use flaps as bookmarks. 6. A Decoration. Books and book jackets help us decorate our living spaces. They allow us to live prettily amongst our accumulated wisdom. (Presuming that we have *read* our books.)

7. A Name Tag; A Secret Handshake. Books (like cars, clothes, etc.) telegraph *who we are*. If you see someone reading *Fifty Shades of Grey,* you may make assumptions about them which will you will most likely not extend to that person on the subway reading *The Phenomenology of Spirit*. In this way book jackets are *advertisements for ourselves*. 8. A Teaser. A jacket is also a *teaser,* in the sense of *a trailer*: in that it should give us just enough information to *entice*. 9. A Trophy. "Just *look* at what *I've* read!" 10. A Carnival Barker; Billboard; Advertisement. Jackets are expected to help sell books. And so they do—they wheedle, shout, joke, cajole, wink, grovel, and otherwise pander in every possible way in order to get a consumer to pick up a given text. 11. A Translation. The jacket is a *rendition* of a book; a *reading* of it; an *enactment*. Is the book jacket necessary? *No.*

F a novel by Daniel Kehlmann

Translated
from the German by
Carol Brown Janeway

This is the only cover I've designed that required extra programming skills to render (someone else's that is). The skull was rendered in the Processing software.

Mr. Peanut by Adam Ross

a novel

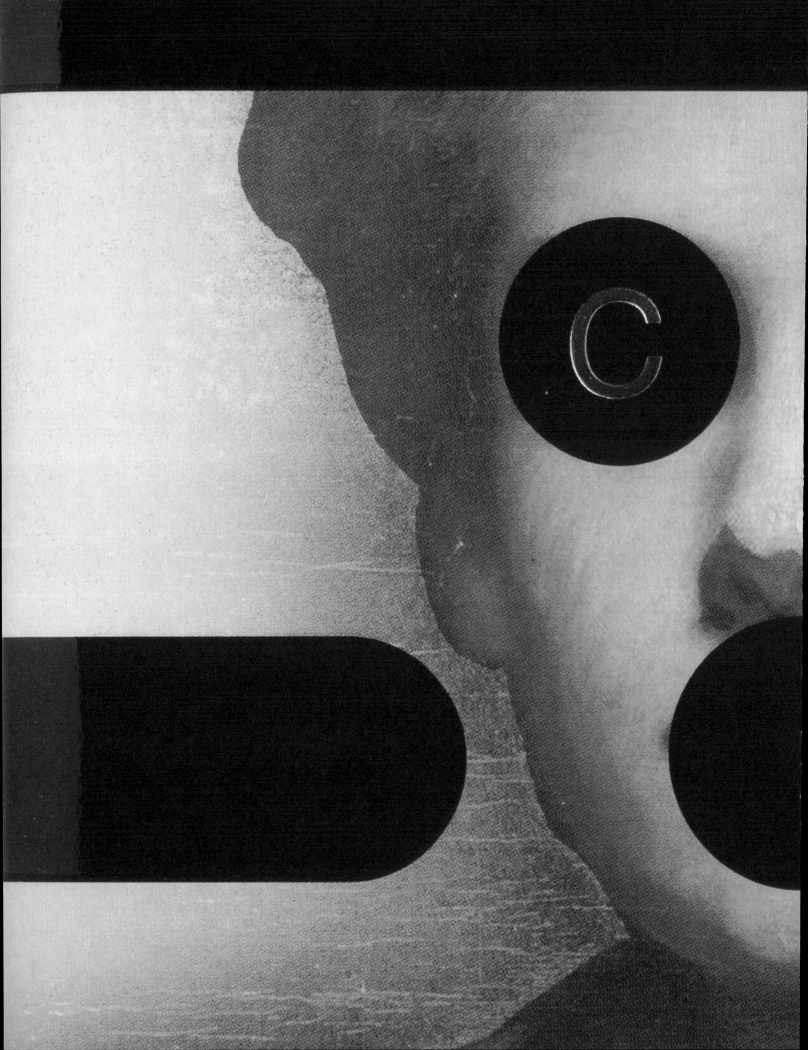

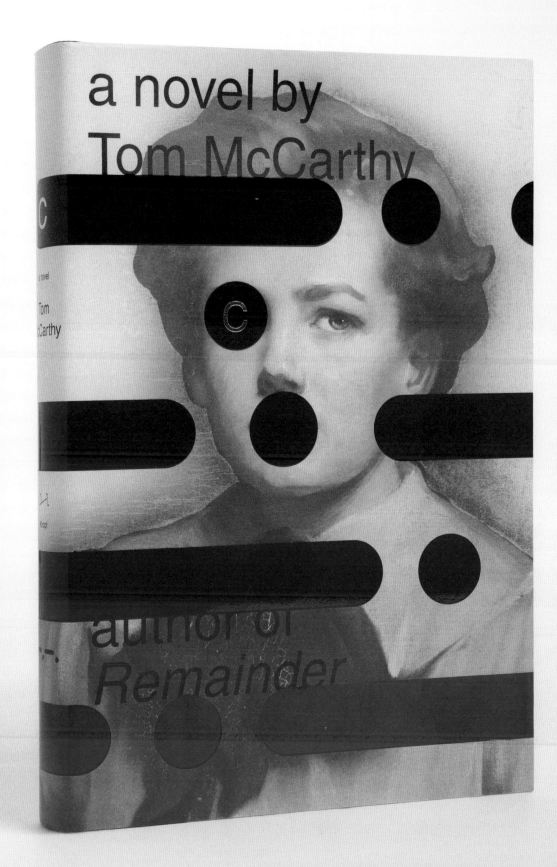

a novel by
Tom McCarthy

author of
Remainder

A boy beset by codes. The symbols over his eye, and the one that appears on, but almost *in* his mouth, have an aspect of affliction (an eye-patch and a ball-gag) as well as an aspect of adornment. It's a strange image — and purposefully off-putting in its implicit violence. I was trying here, mostly, to represent the protagonist's *Slothropian* relationship to technology.

There are
moments
in my day
where
I stop and
think,
"I get paid...
to make
collages!"

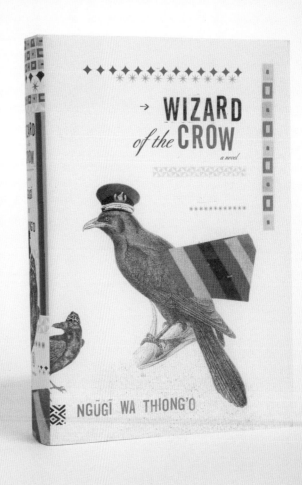

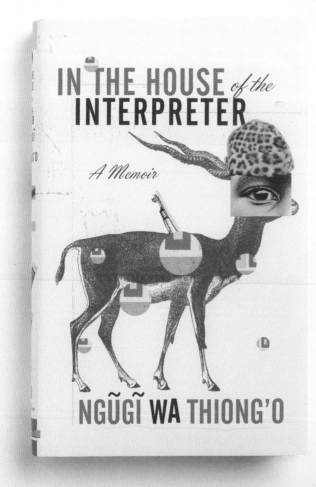

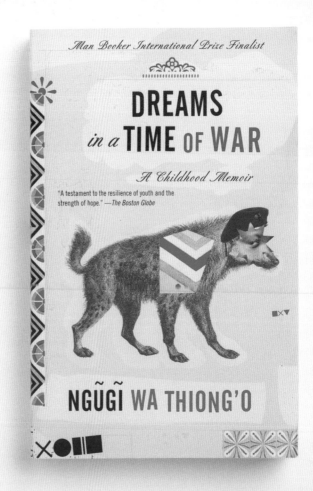

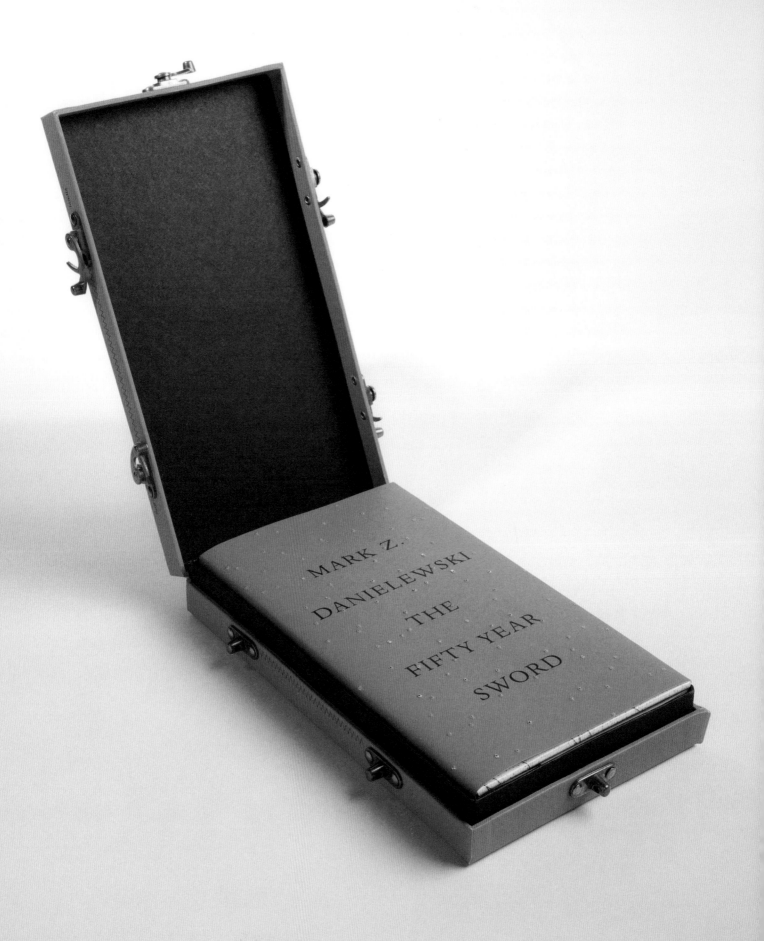

By Mark Z. Danielewski

If once thread—carefully colored and correctly stitched—could make sense of all those holes your pinwheel, your apparatus, inscribed on our cover, in order to tell us something, a secret, maybe even something more than a secret ...

that thread now is gone and the means to rethread such inkless lacunae lost. Instead our cover resembles Kafka's apparatus at the end of "In the Penal Colony" as it fails, a murder without sentence, a sentence without language, yet still revealing beneath itself a murder, or the possibility of a murder, in the language of image, an image which, though once stitched and perhaps even complete, still defies sense...Where "the sentence" is the linguistic point dominating "In the Penal Colony," "the stitch," as we both discussed, is what binds *The Fifty Year Sword*. How we stitch together letters, words, stories, the lies we need, the history we heed, the reasons we reach for to justify what we do or don't do next. And, of course, the opposite, embodied in this cover for all to feel: how we unstitch our secrets, our pains, our truths, our loves, and what that leaves behind.

T50YS

M.z.D.

The five-latched box — one latch
for each orphan in the tale.

MARK Z.

DANIELEWSKI

THE

FIFTY YEAR

SWORD

A special implement was created in China for the perforation of this jacket: a spiked axle
which turns as the jackets come off the line. It punctures each jacket uniquely.

A nod to Nag Champa.

The Immortals

Amit Chaudhuri

A novel

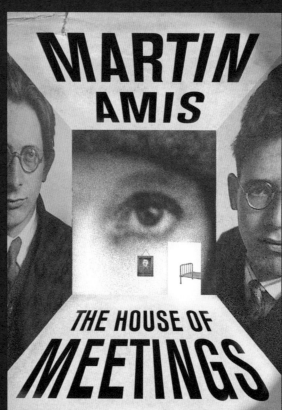

AT LEFT: The sketch; my Photoshop mock-up of the jacket; AT TOP: the photo shoot of the simulacrum room; and AT RIGHT: the final book. (The portrait of Stalin is hanging from a real, tiny brass nail.)

Something

is out there.

Stories by

Richard Bausch

I very badly wanted the entire front of this jacket to read as a single sentence. I can't remember what the editorial objections were to this idea, but, in the process of bowing to the wishes of others I ended up with one sentence followed by a not-sentence. Let's pretend the second period is behind the woman's shoulder, shall we?

One
More
Story.

Thirteen
Stories
in the
Time-
Honored
Mode.
by

Ingo
Schulze

About half of my job consists of the aesthetic minimization of
typography. (The other half is the covering-up of people's faces.)

Silence Once Begun
Jesse Ball

沈
黙

a NOVEL

"He had a very odd way at that time, a very odd way of holding his mouth. I think it was because he had stopped talking. Maybe if people didn't use their mouths for talking anymore, this is the way they would all hold their mouths." —J. Ball

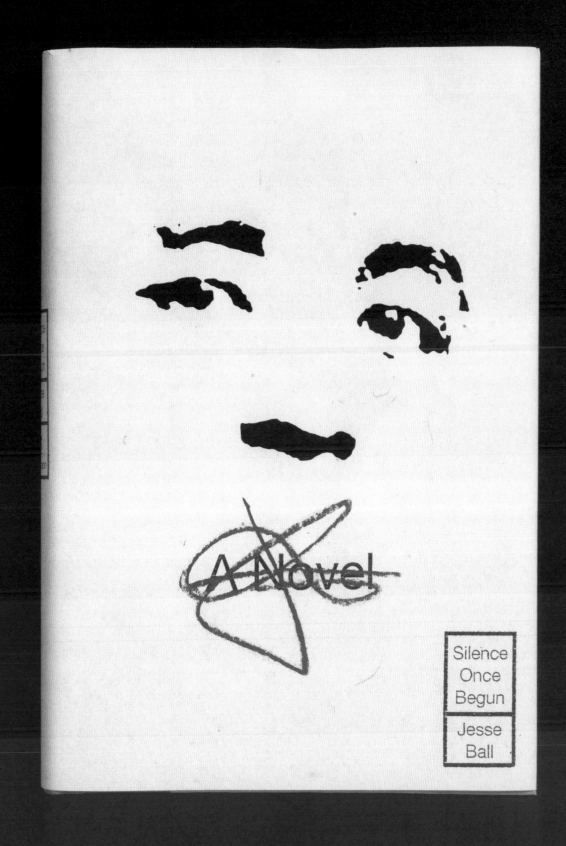

Silence
Once
Begun

Jesse
Ball

Inititally, this jacket had only the words "A novel" on the front, with the rest of the information on the spine —
an idea which I felt meshed so well with the book's theme of "silence." And we came very close to choosing that path.
This was as near as I've ever come to designing a jacket with no title or author name on the front-of-jacket
(a bit of a *holy grail* for jacket designers as we are are always trying to eliminate editorial copy). In the end,
however, it was decided that the title and author name needed to be present, and so I designed them small, and in
the form of a kind of *hanko*, or japanese stamp signature.

"How did you get *that* approved?"

This is the question I'm most frequently asked by other designers, and I find it vaguely insulting.

The implication, here, is that there must be some special dispensation given to my work as it is notably bizarre. One further assumes: 1. There must be an institutional laxity on the approval process on the part of the publishing house endorsing my jackets or 2. I must possess some kind of Svengali-like persuasiveness in the selling of my outlandish comps. Either way, a loophole is necessary to justify agreement to, and approval of, my ideas. (Strangely, now that I look back over the work, I don't see any covers that seem particularly outré or overly daring. Perhaps some of these comps were somewhat adventurous at the time they were pitched, but they all now seem rather tame to me. It's not like there are any particularly strange production techniques, morally or politically deviant imagery, radically unnerving or novel concepts… It makes me wonder why I am asked this question so often.)

In any case, as an exercise—assuming the question is, more often than not, posed in earnest—let's posit some generalized responses…

How to get your crackpot design schemes approved:

* Do good work—as often as possible. Make jackets which are appropriate for the books they wrap. No jacket seems too crazy if it is pertinent to the text it enacts.
* Tune-in and perform well on the last round. If your twentieth round is your best work, your best work will get made. (This is not easy to do. Frustration sets in—this is human nature. Still.)
* Have access to the client (by which I mean: demand access to the client). Disintermediate the middlemen. Insinuate yourself. Find out who makes the big decisions, seek them out, and earn their respect. Also: demand respect. Book publishing may be one of the last businesses where the design department is not considered one of the most important constituencies in the room. This is super weird, and, frankly, wrong. Remedy this.
* Work in volume. The law of averages suggests that eventually you will produce some work you will be proud of. The more work you do, the better chance you have of producing this "good" work. This is to say, most of the work I make is just awful. My better work is propped up by an invisible pile of crappy, lazy, trite, dreck.
* Generate your own projects. This makes you the sole approver.
* Be a diligent and hard worker. Exceed your mandate.
* Be a close reader.
* Enhance your reputation, whenever possible, in the world outside of book publishing. These things redound.

* Know your shit. Be smart.
* Be eloquent.
* Be willing to participate. Provide evidence for your beliefs.
* Speak truth to power (respectfully).
* Question conventional wisdom. Debunk myths. Point out fallacies. (For instance, a common fallacy you might encounter is the fallacy of false association: book X succeeded/failed and had Y kind of cover, therefore, a cover like Y is intrinsically good/bad.)
* Remember that all marketing knowledge is retrospective—it tells us what has worked in the past, but not what will work today or in the future. Design should concern itself with manufacturing desire. There is no science to this. But if you study the culture (readers/viewers/consumers) you will glean some of its wants and needs (again, not what the culture's wants and needs *were,* but, rather, what they are and will be).
* An editor or author may know more about a book and its audience than you do, but also: they may not.
* "Why?" is always a valuable question to ask.
* Know the product. Know those who purchase the product. Know those who sell the product. We now have more access to book buyers, sales reps, clerks, readers, than ever before. Take advantage of these relationships and the data that comes with them.
* Realize that not every hill is a hill to die on. Decide where to plant your flag. Triage your jobs and manage your time accordingly.
* Minimize the institutionally calcified practice of "uglification." Uglification is a process in which designers—by request or demand—make their work uglier, one detail at a time (Can you change the font?; I don't like red; Can you use a different picture…? etc., ad nauseam, ad absurdum.) Uglification is what happens when final decisions about how something looks are made by people not qualified to make aesthetic judgements.
* As an addendum to this last: examine, publicly, the question, "Who gets a vote, and why should they?"
* Don't lose hope. Remember that it's bad out there for all of us. Some publishing houses treat their designers a tad better than others, but at almost all publishing houses, designers are still considered a lower caste. This is not OK—nevertheless, as Beaumarchais reminds us, the servant class (the downstairs staff) always has more fun, and are, generally speaking, shrewder and savvier than the aristocracy they serve.
* Be a citizen of the world, and at least attempt to know a little something about life outside of your own InDesign files. Be aware that, in the end, when all is said and done, this thing we do, design, is a kind of joyous little game, and we are lucky to be paid to play it. Meanwhile, others watch stock tickers or change bedpans for a living. Have some perspective and be grateful. Engage in something that matters to you more than your latest project. Some perspective and a modicum of circumspection will improve your mood, expand your horizons, and improve your design work.

By Steven Amsterdam

At the turn of the century,

I was an assistant designer at Knopf, hunkered down with a Mac at a book-stacked cubicle in a corridor. I was there for the exacting and forgiving Carol Devine Carson. My design training was slim, but she saw other skills in my past as potential sources for a developing aesthetic. The job was to produce back ads, promotional materials, manage cover production for a never-ending series of travel books, and to design a few jackets. Because each project took me into some other realm (a love triangle in WWI Austria, starvation on the Santa Fe Trail, an ode to the color turquoise), this was one of the finest jobs I'd ever had.

The job also gave me the endless gift of Peter Mendelsund. He occupied the cubicle across from mine, where he performed similar work for John Gall—also gladly. His design training was even slimmer than mine, but his excellence was already there. Coming from the outside world into the rarefied air of this art department, we bonded, over the circuitous routes of our lives and over lunch in the Random House cafeteria. Throughout the day I would look over wistfully at his screen and see that his visual smarts were steadily sharpening. He brought literacy (about the world, not just its books) to every project, giving his designs a fierce but never showy intelligence. Mine were fine, but OK. When I finally got the nerve to move on, he moved up. These were the right directions for both of us.

Five years later, I'm getting my first novel published. I didn't waste too much time thinking I would be up to the task of doing the jacket. Peter had been reading my drafts, plus, he was the best designer I knew (and know). A few weeks after agreeing to give it some thought he humbly submitted a perfect design, which with minor adjustments became the jacket you see before you.

At first, what looks like a printer's error catches your eye; then you assemble the title and you get it—the type leading you into the unseeable future (and, one hopes, the book). It was spare and effective, appropriate for the content. It wasn't a Peter Mendelsund jacket, it was the right jacket for the book. That night my publishers wrapped a printout of the comp around a hardcover book, propped it up on a table at a bar and we toasted the mock up with a favorite bookseller. For me, this was when the project became real.

Of course after the buzz, marketing doubt set in. Some folks didn't get it; they were only confused. They needed more guidance. I've located the email where I made the classic author suggestions that should be ignored: Are you sure Baskerville is right? Can you put a picture behind it? Should you change the color of the type? Peter graciously declined to consider any of it.

The design was used in the U.S., Australia, and, with modifications, the U.K. and France (where they stuck a picture behind it). The type treatment and the wrap became the brand for the book in all these markets, which is exceedingly rare. The only other praise I can give is to say that whenever the cover catches my eye (and it always does; I wrote the thing), I instantly recognize it as a part of myself. Every author should be so lucky.

We Things V
See Didn't S
hing Comi
ven by Stev
am Amsterda

Jacket as movie screen; title as subtitle.

"Style is not neutral; it gives moral directions."
—M. Amis

My cover-design homage
to the big post-war novels
my parents had on their
shelves: books such as LIFE
AND FATE and ONE DAY IN
THE LIFE OF IVAN DENISOVICH.

on occasion even

written of

. At any rate, I

s that I like, that I have

toward darkness or bloody

in.

A story with

light.

not make my

The jacket contains a censor-evading coded message (the purple dots).

I am an Iranian writer ~~tired of~~ writing ~~dark and bitter~~ ~~stories, stories populated with ghosts and dead~~ narrators with ~~predictable endings of death and destruction.~~ I am a writer ~~who at the threshold of fifty has~~ understood that ~~the purportedly real world around us has enough death~~ and ~~destruction and~~ sorrow, and that I did not have the ~~right to add even more defeat and hopelessness to it with~~ ~~my stories. In my stories and novels there are men~~ whom I ~~have created with~~ a ~~body and romantic valor~~ that I do not possess. ~~Similarly, there are women whose bodies and~~ ~~personalities I have reproduced from the body and soul of~~ ~~the woman who~~ ... ~~dreams—although~~ I have ~~never~~ ... ~~fantasy~~ woman ... certain ~~other women. Between ... on occasion even~~ ~~exerted ... this~~ fantasy ... ~~imagined and~~ written of her ~~blond~~ hair as black ~~and once as auburn~~. At any rate, I ~~... myself for sending characters that I like, that I have~~ ~~... created~~ word by word, ~~toward darkness or~~ bloody death ~~at the end of my stories like Doctor Frankenstein~~. For these reasons, ~~and for reasons that like other writers I will probably discover later, I, with all my be-~~ ~~...~~ want to write a love story. ~~... love story of a girl~~ ~~who has never seen the man ... falling in love with him~~ ~~... and ... loves very much.~~ A story with an ~~ending that is a~~ gateway to light. ~~A story that al-~~ though it ~~does not ... ending like ... does~~ ... not make my ~~reader afraid of falling in love. ... of course, I won~~ ~~...~~ ~~be labeled as political. My dilemma is that~~ ~~I want to publish my love story in my homeland . . .~~

CENSORING AN IRANIAN LOVE STORY.
a novel.
Shahriar Mandanipour.

Peter

A novel

Parrot & Olivier
in America

Carey

Two-time winner of the Booker Prize

Ocean
☐

Sand
☐

Gravity
☐

Male
☐

Female
☐

Solitary
☐

Lonely
☐

Torus
☐

Brane
☐

Loop
☐

Real
☑

Sorry
☑

Please
☑

Thank You
☑

Charles Yu
🏛

Pantheon

By Charles Yu

The first time I saw the cover for *Sorry Please Thank You*, I felt instantly better and worse.

Better because it had extracted something essential from my stories and distilled it into one pure and clear idea. Worse because I realized my stories didn't quite live up to that purity or clarity. I think a great designer like Peter Mendelsund is like a photographer, armed not with a literal camera but with a conceptual one. And with that conceptual camera he reframed the contents of my book for me, found the one best angle to shoot them from, and with a single, exacting shot he captured all thirteen stories.

☐ Sorry

☐ Please

☐ Thank You

☑ Stories

☐ Charles Yu

☐ author of
How to Live Safely in a
Science Fictional Universe

SCOTT
THE
RUINS

KNOPF

ROBERT HARRIS

14% 37.47M 3.

THE FEAR
INDEX

.47M KNOPF =0.2

>>> >>>

P. D.
JAMES

THE LIGHTHOUSE

AN
ADAM DALGLIESH
MYSTERY

KNOPF

easy money Jens Lapidus

Pantheon

LEATHER MAIDEN
JOE R. LANSDALE

KNOPF

THE GIRL
WITH THE
DRAGON
TATTOO

STIEG
LARSSON

I

KNOPF

THE GIRL
WHO PLAYED
WITH
FIRE

STIEG
LARSSON

II

KNOPF

THE GIRL
WHO
KICKED THE
HORNET'S NEST

STIEG
LARSSON

III

KNOPF

Th
Rede

Jo
nesbø

Genre
Fiction

"It needs more blood."
—Sales and Marketing

Jo

Nesbø

The

Snowman

a novel

Jackets for crime books are strange things.

I've always worked closely with my designers in Norway, both on ideas and presentation. Not because I have any idea of what covers will sell a book, but because the way I see it, my story starts with the cover. I'm lucky to be published in several countries which means several jackets. I soon discovered I should not be too involved in the making of international jackets. Each country has its own style, tradition, and inherited set of visual references that sometimes feels as different as our languages. And I must admit that more often than not I look at my international covers and I don't get it nor like it, I just hope it make sense to its audience in that country and tell myself that most people forget the jackets once they've started reading. But once in a while I'm presented with a design that crosses the barriers of cultural references and visual language, that feels universal, that feels like the perfect start to the story. A jacket that I don't want to reader to forget, but to carry with them throughout the book. Those covers are Peter Mendelsund's covers for my Harry Hole series.

Despite eschewing all the tropes of horror design, the above won several awards for best "genre" cover. Which just goes to show...er, *something or other.*

The edge stain: expensive, but *so luxurious*.

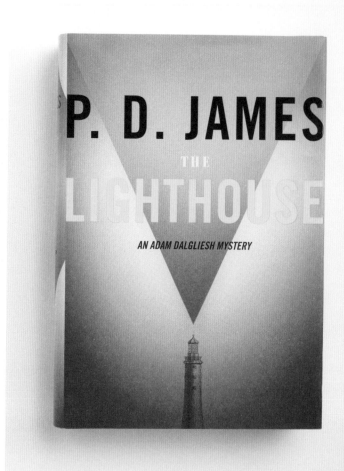

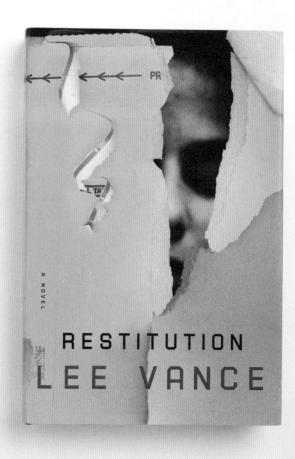

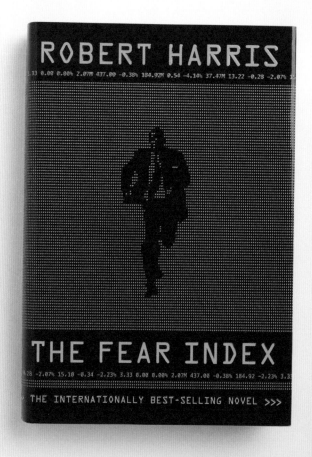

FAR LEFT:
Yes, that
is, indeed
a *novel*
by Marlon
Brando.

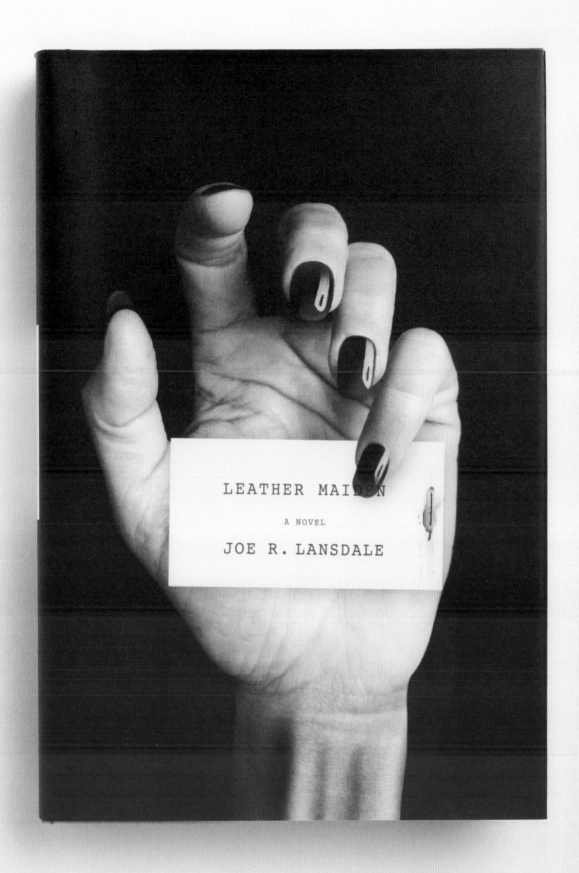

The hand of a fellow designer. We designers are always volunteering to act
as models for one another's book covers. I've used four coworkers as corpses to date.

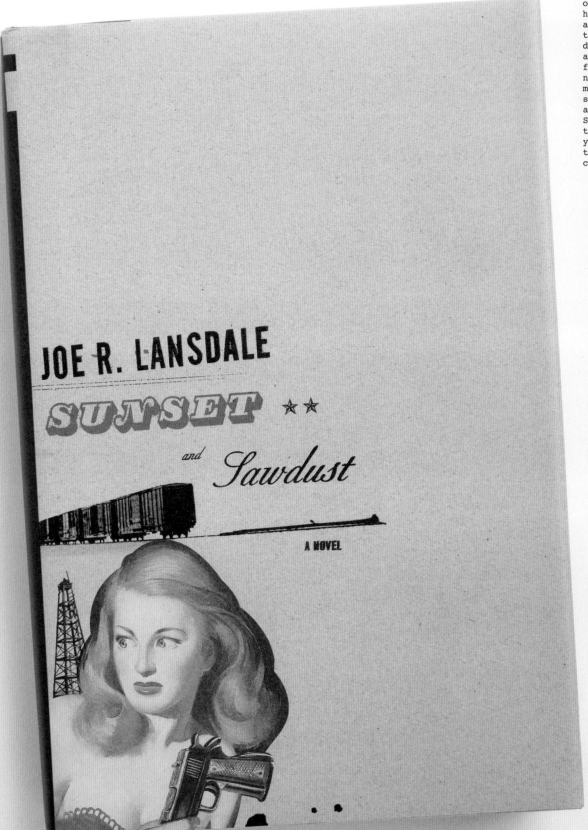

In the opening pages of this book, a battered wife engaged in the act of killing her husband is beset by a tornado, which in turn: denudes her; destroys her house; and pelts her with frogs. She wanders naked into a nearby mill town, in which she is soon after appointed sheriff. Still later, she teams up with a young hobo in order to solve a horrible crime. (Pulp alert!)

The Sheriff of Yrnameer // Michael Rubens

"Finally, a science fiction book your grandmother will love—
if she's a lustful, violent lady." —Stephen Colbert

Sadclops.

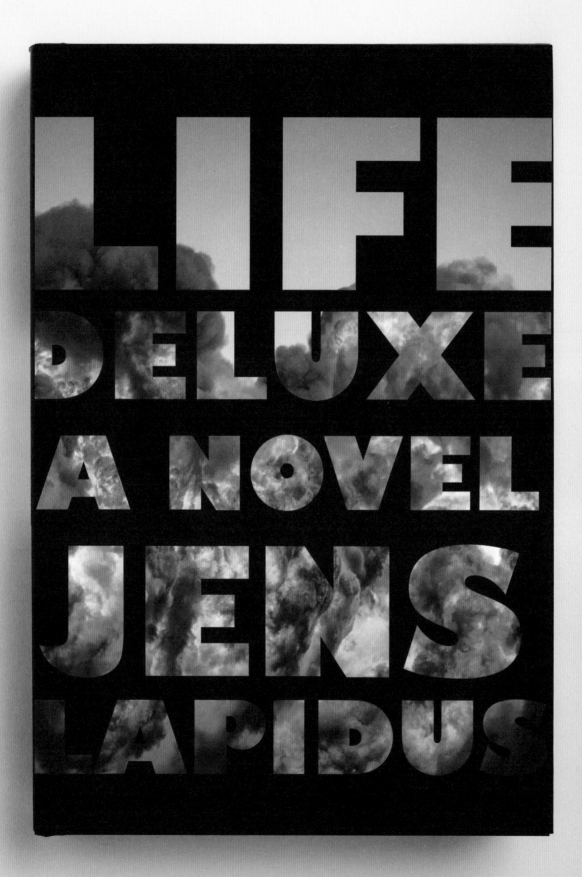

Kaboom! Jacket as MACGYVER title sequence.

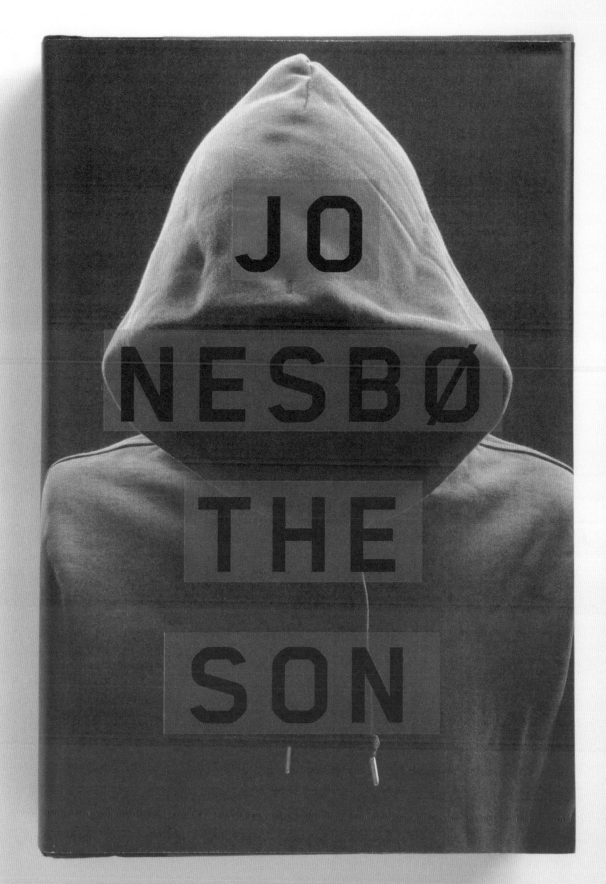

A Jo Nesbø stand-alone.

Never Fück Up

A NOVEL

"It's an entirely new criminal world, beautifully rendered."
—JAMES ELLROY

Jens Lapidus

For this series I imagined a home shopping network for blunt-force weaponry...

THE
GIRL
WITH
THE
DRAGON
TATTOO

A NOVEL STIEG
LARSSON

NATIONAL BEST SELLER

"I have a book I'd like you to work on—it's a Swedish crime novel called *The Man Who Hated Women*."
—Sonny Mehta

The bright yellow cover of Stieg Larsson's *The Girl With the Dragon Tattoo*, featuring a swirling dragon design, has become one of the most instantly recognizable and iconic book covers in contemporary fiction in the U.S.

But the path to this design—like the thriller—has been full of twists, red herrings, and wrong turns.

Sonny Mehta, chairman and editor in chief of Knopf Doubleday Publishing Group, bought publishing rights to the novel at auction in 2007. The book was already a best-seller in Europe, but Knopf executives fretted about how the international covers would sell in the U.S. Mr. Mehta found the images on the British, Serbian, and Chinese covers—sexy pictures of women with dragon-shaped tattoos—distasteful, describing them as "somewhat redundant" and "cheesy."

For three months, Peter Mendelsund, a senior designer at Knopf, prepared nearly 50 distinct designs. Mr. Mendelsund, age 42, graduated from Columbia University in 1990 with a degree in philosophy and worked as a professional musician for more than a decade before embarking on a design career. With no formal graphic design experience, he began drafting CD album covers for an indie label. Less than six months later, a family friend introduced him to Chip Kidd, Knopf's associate art director. Mr. Mendelsund showed Mr. Kidd his portfolio; he had a full-time job at Vintage Books, a Random House label, within the week. Eight months later he was at Knopf, his home for the last eight years.

One Mendelsund design, a monochromatic white cover dotted with blood, was rejected for its lack of color. Another, a vivid fuchsia jacket emblazoned with an illuminated typeface, left executives looking for something more original.

A third showcased the book's early working title, "The Man Who Hated Women," which was closer to the original Swedish title. Mr. Mendelsund liked the image of an anonymous woman, with its "contrast between the softness of her face and the way it has been shredded." But the title went out—for fear, Knopf says, that it would be "problematic" in a U.S. market—and the jacket did, too.

Mr. Mehta ultimately endorsed the vivid yellow jacket with the swirling dragon design: "It was striking and it was different."

Not everyone loved the jacket. Mr. Mehta said there was "some push back" from retailers, as well as members of the publishing house's sales team, who were looking for a more conventional depiction in lines with other thrillers—something darker, bloodier, "more Scandinavian." Yet Mr. Mehta stood by Mr. Mendelsund's distinctive design. Mr. Mehta said he didn't want the books to be pigeonholed: "I was extremely worried that they would be dismissed as crime novels, Scandinavian crime novels, in translation."

The Knopf chairman said he had, at the time, "been disappointed" by the U.S. presentation and sales of books by Swedish crime writer Henning Mankell, and did not want Mr. Larsson's Millennium Trilogy to post similar numbers. (Since then Knopf has released its first hardcover from Mr. Mankell, *The Man From Beijing*, which made the best-seller lists this spring.) *Dragon Tattoo* has sold 3.8 million copies in the U.S. to date.

My first comp. We came very close to using this white-on-white jacket. This design did a better job of
representing the narrative than the final, though, perhaps, would have done a poorer job selling the book.

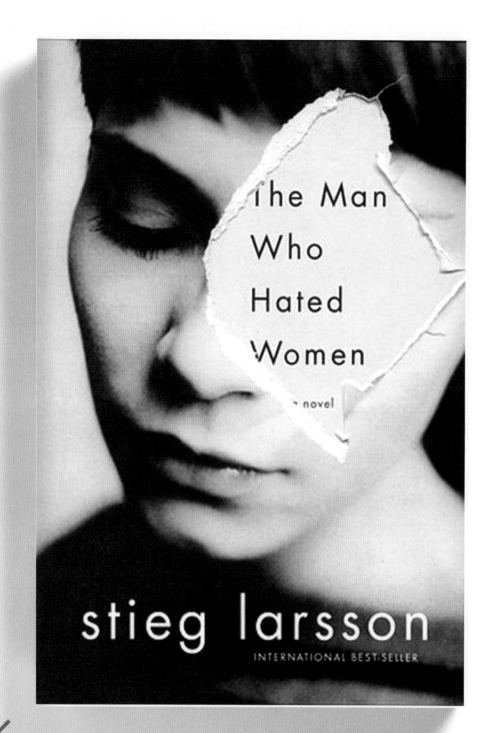

There was a moment, early on,
where this was the book's title.
Thank god it changed. (ABOVE)

These three comps above, along
with dozens of others, were
responses to various suggestions
from multiple interested parties.

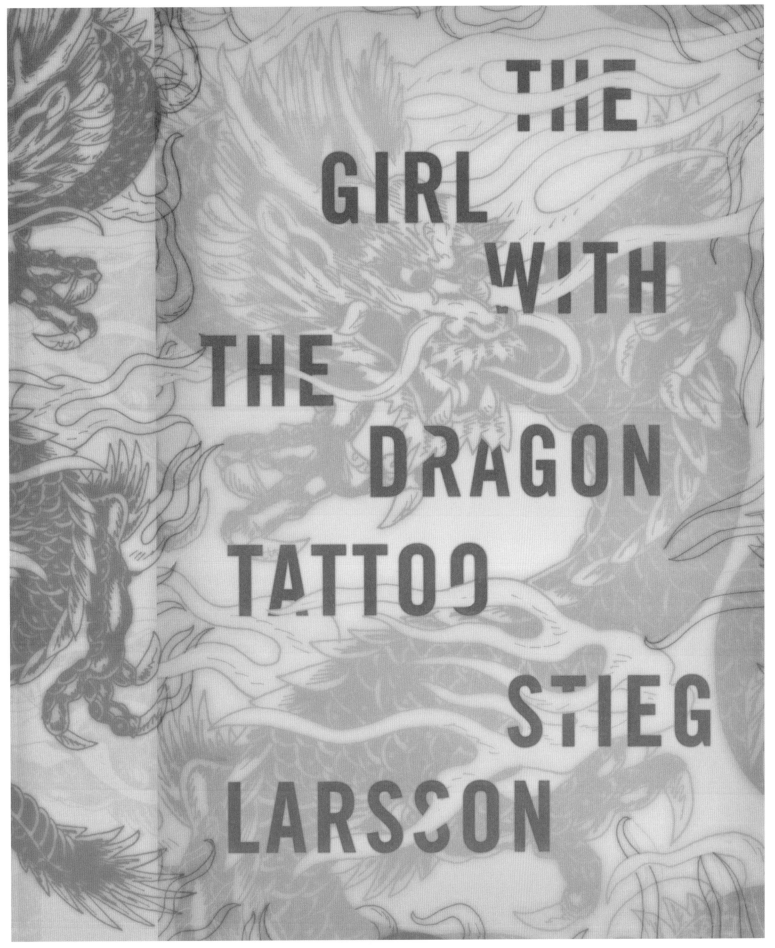

THE GIRL WITH THE DRAGON TATTOO

STIEG LARSSON

Almost final. My first inclination was to use the colors of a tattoo...but brighter colors won the day.

The first sketch for THE GIRL WHO PLAYED WITH FIRE.

Then rendered by Charles Burns.

My daughter Violet, on the Xerox copier.

THE GIRL WHO PLAYED WITH FIRE

STIEG LARSSON

THE GIRL WHO PLAYED WITH FIRE

A NOVEL

STIEG LARSSON

AUTHOR OF THE INTERNATIONAL BEST SELLER
THE GIRL WITH THE DRAGON TATTOO

The final. Over the years I've heard many people refer to this book mistakenly as "The Girl Whose Hair Was on Fire."

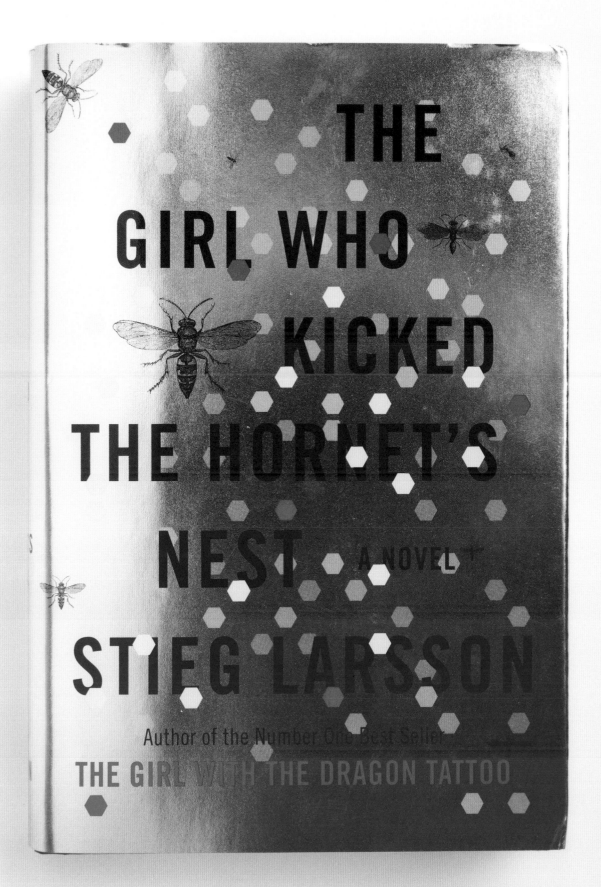

By the time volume three came out, I was pretty sure I could have
put just about anything on its cover and it would still sell.

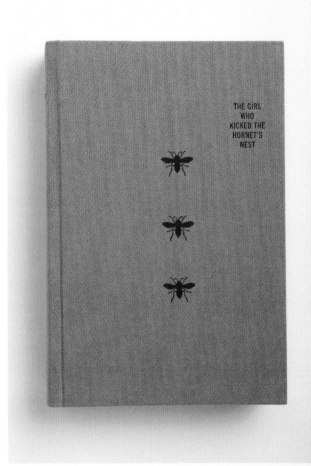

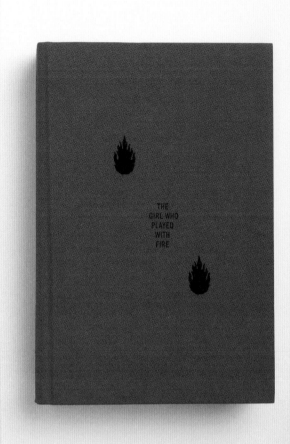

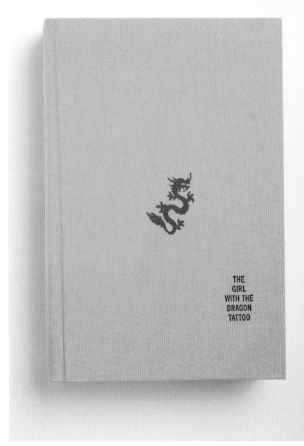

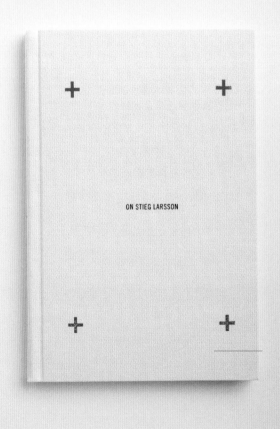

The special
edition books were
pigment-stamped
cloth.

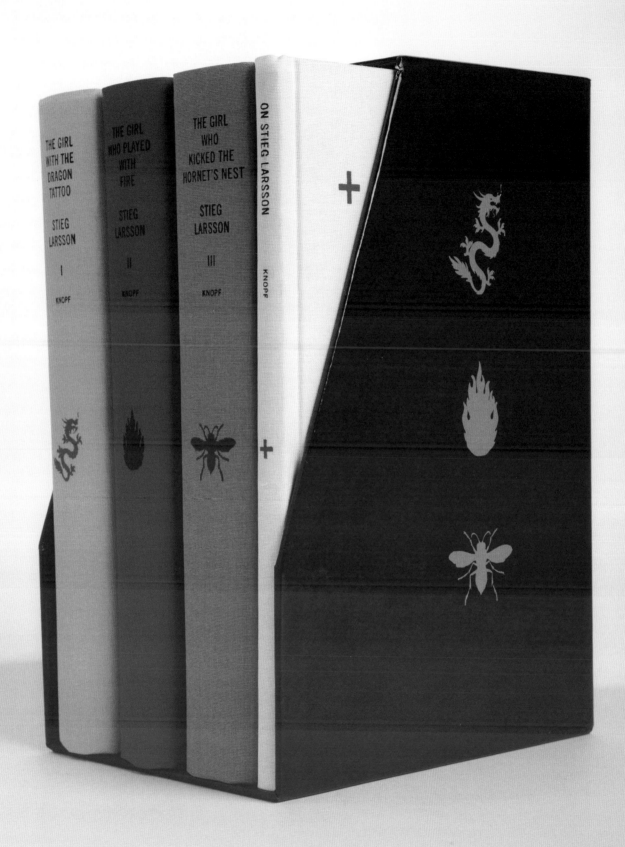

The special edition boxed set.

Nonfiction & Poetry

Confidential

Cigarettes DO NOT

TELLS THE FACTS AND NAMES THE

Shocking True Story

BY HENRY SCOTT

The
and
CONFID
"Amer
Mo
SCAND
Scar
Maga

PARLOR,
AND BABE
TONY

LANA TURNER SHARED
VER WITH AVA GARDNER

It could only happen in Hollywood!

That Blonde Sharing
Nick Ray's Pillow Was
MARILYN MONROE!

Shocking True Story

HENRY E. SCOTT

Most Coveted
Phone Numbe
shington, D.

public 7-357

A call girl ring in

The truth as gold-standard brick.

ON
TRUTH

HARRY G.
FRANKFURT

AUTHOR OF
ON BULLSHIT

JAMES

THE INFORMATION

A HISTORY, A THEORY, A FLOOD.

GLEICK

By James Gleick

I met Peter Mendelsund in October 2010 and discovered a few days later that I was the bane of his existence.

I came across his blog, called "Jacket Mechanical." It featured the most extraordinary collection of book-related artistry, new and old, that I'd ever seen, amid a baffling sea of erudition, allusions to anything from James Joyce (which I caught) to György Kepes (which I did not). But there was also a pointer to a website called "From the Desk of…" with an annotated photograph of Peter's desk. In the foreground I could see some proposed jackets for my own soon-to-be published book. Annotated thusly: "2. Pantheon's science writers have been, of late, the bane of my existence. Reject after reject. Here we see the fruits of my recent labors." Ouch! Burn! Well, it was true that I had made a rare visit to the Pantheon office and had seen his "comps" (is that the right word?) for my book and expressed some doubts—in what I hoped was a mild and tentative way. Here, on the left, is one proposed jacket, for example. Now that I look at it afresh, at leisure, with nothing at stake, I see that it's striking and clever. At the time, it just struck me as a puzzle I didn't want to solve. It gave me a headache, which I suppose I may have passed on to Peter.

What kind of cover did I want? I had no idea. I never do. And if I did, I wouldn't know how to express it. Can you sum up a book in a single image? Is the jacket meant to encapsulate the book or interpret it; to convey its essence, or just to give the buyer a hint of whether it's sexy or serious?

Consider the authors' plight. At long last our creation is going forth into the world, a poor, bare, forked thing. It needs clothing. We may care intensely—desperately—about the book's visual presentation. The jacket is all that most people will see. It begins to represent not only our text but our very selves.

We authors are uniquely positioned to appreciate the book's virtues (never mind its flaws). We have inside knowledge, in other words. But you don't ask the horse to handicap the Preakness.

I'm in awe of Vladimir Nabokov's famous instructions to the designers at Putnam regarding the jacket he wanted for *Lolita*:
"I want pure colors, melting clouds, accurately drawn details, a sunburst above a receding road with the light reflected in furrows and ruts after rain. And no girls."

I'd like to see that jacket. How vivid these instructions are! (Fat lot of good it did him, though.)

By James Gleick

After six books, I can recall only one occasion when I tried to give my publisher specific direction. It was for my biography of Isaac Newton, and the sum total of my conception for the cover design could be boiled down to two words: "No apples." There were some arguments, but I got no apples.

As for *The Information*, I don't know whether my incoherent whining helped or hurt. Peter's next version was the one you see. Was I happy yet? I vacillated. I wondered whether anyone but the cleverest and most persistent reader would be able to figure out the book's subtitle, A History, a Theory, a Flood. I wondered whether anyone ten feet away would be able to see anything at all. Anyway, by then it hardly mattered what I thought. The market for my opinion was plunging like the stock exchange on Black Friday. This was conveyed to me with a simple phrase ("Sonny likes it.") spoken softly and meaningfully.

You'll judge for yourself whether Sonny was right, but by the time I had the actual book in my hand I had decided that the design was brilliant—original and strange. The jacket does not try to represent the whole book—can any cover ever do that?—but captures some essential idea of it and expresses it in a subtle, sidelong way, which I don't think I should try to analyze in words. Eventually, Design Observer and the AIGA recognized this cover as one of the year's best. Several of my foreign publishers have copied it for their

editions, with minor adjustments that invariably detract from the original.

Now Peter has taken on Kafka. He's done Joyce. He's created designs that make me want to repurchase books I already own. And those guys never show up in his office to look at his comps with their gimlet eyes.

Not long ago, in an interview I saw online, he remarked:
"I've noticed that dead authors get the best book jackets. I'll let you draw your own conclusions as to why this is…"

I think I know.

Jim Gleick, far from being the "bane of my existence," was a joy to work with. I made two comps prior to his final jacket, and neither was quite right for this book. I am now grateful to the author for requesting that I keep plugging, as the final jacket (AT RIGHT) remains one of my all-time favorites.

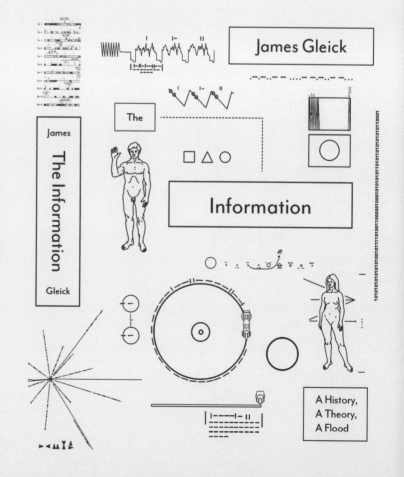

The Information The Information The Information
The Information The Information The Information
The Information The Information The Information
The Information The Information The Information
The Information The Information The Information
The Information The Information By James Gleick
The Information The Information By James Gleick
The Information The Information By James Gleick
The Information The Information By James Gleick
The Information The Information By James Gleick
The Information The Information By James Gleick
The Information The Information By James Gleick
The Information The Information By James Gleick
The Information The Information By James Gleick
The Information The Information By James Gleick
The Information The Information By James Gleick
The Information A Theory, By James Gleick
The Information The Information By James Gleick
The Information The Information By James Gleick
The Information The Information By James Gleick
The Information The Information By James Gleick
The Information The Information Author of *Chaos*
The Information The Information Author of *Chaos*
The Information The Information Author of *Chaos*
A History, The Information Author of *Chaos*
The Information The Information Author of *Chaos*
The Information A Flood Author of *Chaos*
The Information The Information Author of *Chaos*

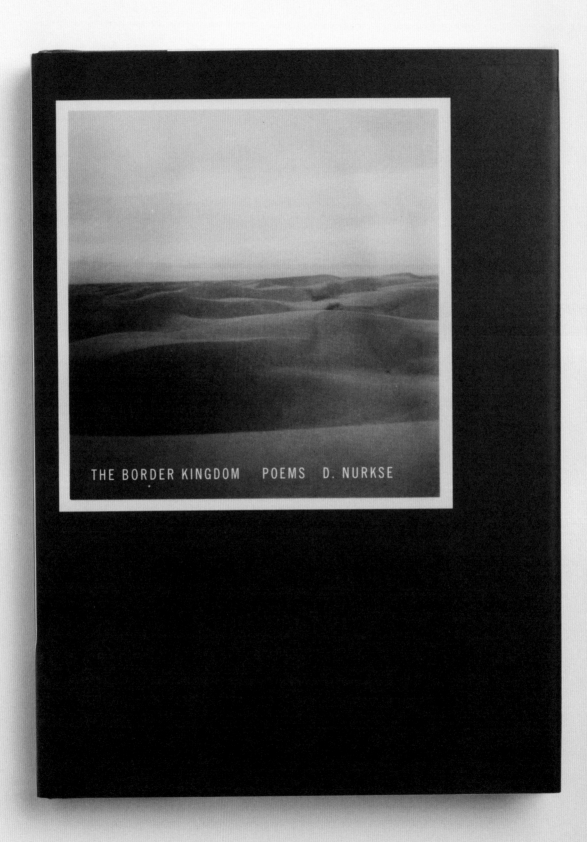

THE BORDER KINGDOM POEMS D. NURKSE

A found photo.

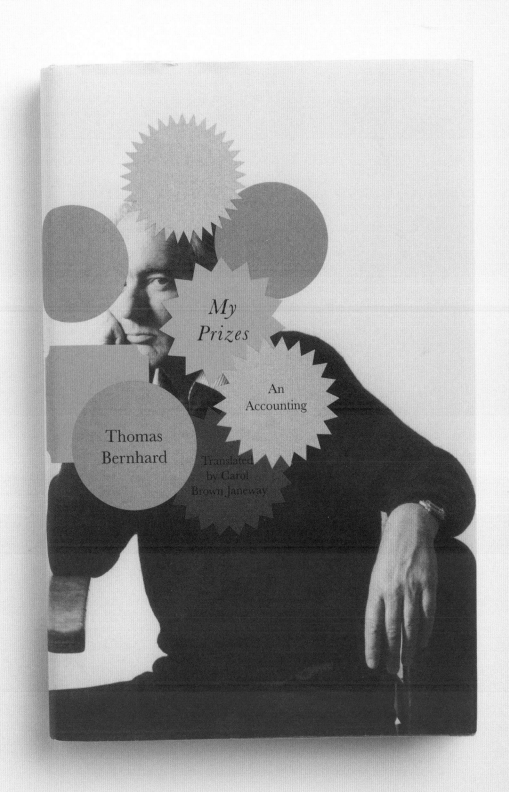

Subliminal Leonard Mlodinow

Pantheon

Subliminal

How Your Unconscious Mind Rules Your Behavior

Pssst... Hey There. Yes: You, Sexy. Buy This Book Now. You Know You Want It.

Leonard Mlodinow

Author of the Best Seller THE DRUNKARD'S WALK

The text on the right half of the jacket was
blind spot-glossed; so it only was visible from certain angles.

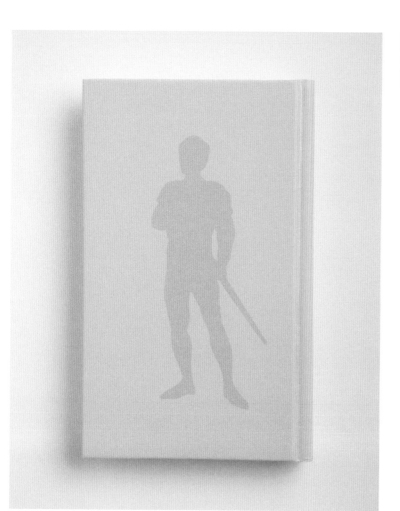

Making use of
the inherent
drama of a
semi-opaque
material.

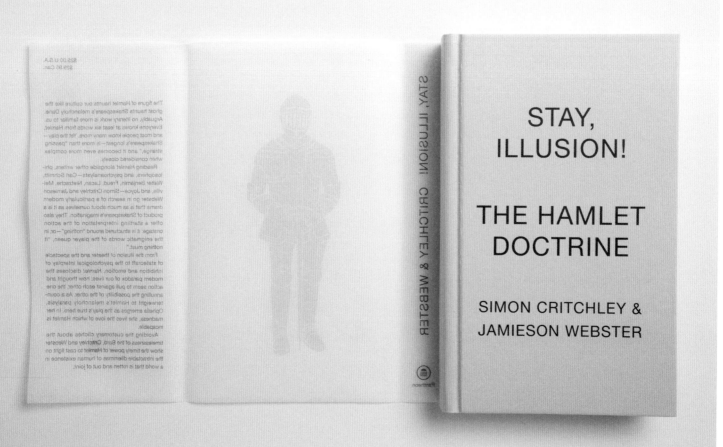

China in Ten Words

People 人民 Leader 领袖

Reading 阅读 Writing 写作 Lu Xun 鲁迅

Revolution 革命 Disparity 差距 Grassroots 草根

Copycat 山寨 Bamboozle 忽悠 by Yu Hua

Rubber stamps were made in order to create this jacket.

Turing's Cathedral

THE ORIGINS OF THE DIGITAL UNIVERSE

George Dyson

Homage to the Turing punch card. Jacket is die-cut.

Alan Turing on the book's casewrap.

Mindwise

How We Understand What Others *Think, Believe, Feel,* and *Want*

"Insightful
and important,
Mindwise is one of
the best books of
this or any
other decade."
—Daniel Gilbert,
best-selling
author of
*Stumbling on
Happiness*

Nicholas Epley

While art director at Pantheon Books I was fed a regular diet of neuro-psych books.

INCOGNITO

THE SECRET LIVES
OF THE BRAIN

DAVID
EAGLEMAN

AUTHOR OF **SUM**

The
Optimism Bias

A Tour of the
Irrationally
Positive Brain

Tali Sharot

Self Comes to Mind

Constructing the Conscious Brain

Antonio Damasio

loneliness

Human Nature *and the* Need *for* Social Connection

John T. Cacioppo & William Patrick

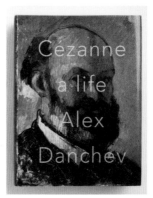

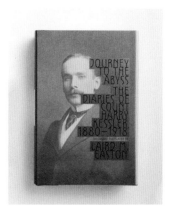

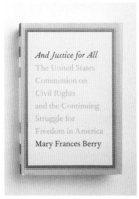

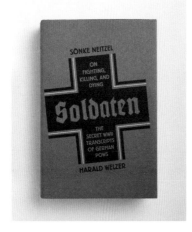

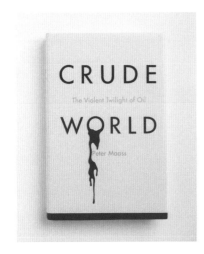

Zen and Now
On the Trail of
Robert Pirsig and the Art of
Motorcycle Maintenance
Mark Richardson

Robert Pirsig's 1964 Honda Super Hawk, the CB77.

The other ninety shades are on the spine and back...

Hair fractals. During the approval process, everyone on the other side of the table seemed pretty bored by this jacket. I only learned later that the effect I was going for was much too subtle, to the extent that nobody had noticed it. Of course, from the designer's perspective, this subtlety is *exactly* the desired effect (a belated, "Aha!" from the reader/shopper).

Bento's Sketchbook

How does the impulse to draw something begin?

John Berger

I looked through the drawings Berger supplied me with, and instead of finding a piece of art to use for his cover,
I ended up falling in love with a tiny hand-scrawled caption of his: "How does the impulse to draw something begin?"

"Use *this*." —James Rosenquist

Sometimes, authors give me images to work with on their covers. Sometimes they make these images themselves.

ANTOINE'S ALPHABET

Watteau and His World

JED PERL

Peter Mendelsund pushes the visual and the verbal into unforeseen alliances.

Once we've seen these alliances, they feel inevitable. He establishes exactly the right balance between the timely and the timeless. He engages with all the fashionable tropes, trills, and frills of our on-the-go culture, while remaining grounded in a rigorous formal logic. He studied piano very seriously before turning to a career in the graphic arts, and he brings some of the classical musician's intrepid union of discipline and abandon to his savory and subtle designs. I mean it as a high compliment when I say that the art of Peter Mendelsund is the art of an old soul. Of course he's also a bit of a hipster. Somehow it all fits together.

The cover designer's work is a matter of signs, symbols, and suggestions. Readers are looking for hints and clues, and they may well be frustrated if the clues turn out to be conundrums. The content of the book must be revealed—although only up to a point. Mendelsund understands this. He has the intellectual's awareness that ideas can be simplified without being reduced. For a new paperback edition of *Illuminations,* the seminal collection of Walter Benjamin's essays edited by Hannah Arendt, he created a cover that is a network of interlocking and overlapping white lines, embossed on a deep orange ground. The cover becomes a map of a neighborhood or even

a metropolis, emblematic of Benjamin's obsession with the Baudelairean flâneur who discovers the secrets of Berlin, Paris, Moscow, or Marseille as he walks the city streets. Let me mention one more of my favorites among Mendelsund's covers. For Roberto Calasso's *Tiepolo Pink*, a meandering exploration of the Venetian painter whose trompe l'oeil ceilings are among the treasures of eighteenth-century art, Mendelsund created a design in which playful rococo color and striking spatial recession are reconciled with a crisp modern sensibility. A voluptuous vision is given an angular salute.

But if I am delighted to be a reader of books with covers that Peter Mendelsund has designed, that is nothing compared to the happiness I've experienced as a writer working with Peter on covers for two of my own books. Cover design—I should have said this before—is very much a collaborative art. And part of what I admire in Peter is the way he takes off with an idea, giving form to a writer's thought. When the time came to design a cover for *Antoine's Alphabet,* my study of the eighteenth-century artist Antoine Watteau, there was a meeting with Peter and my editor, Carol Janeway. I brought a number of black-and-white engravings after Watteau's paintings and

drawings, and spread them out on a table for Peter to look at. The three of us talked a bit about the book. Then we went our separate ways. And in what seems in retrospect like a matter of a few days, I had a call from Carol, who was sitting with Peter's first pass at a cover, which she thought was pretty perfect. It was. And it is. It's playful but austere. It's a little bit extravagant and a little bit astringent. Like every great book jacket, Peter's cover for *Antoine's Alphabet* makes promises that an author can only hope to keep.

TIEPOLO PINK

ROBERTO CALASSO

Author of
*THE MARRIAGE OF
CADMUS AND HARMONY*

Tiepolo: a famous painter of ceilings...

What could be more counterintuitive than the
use of photography on a series of books containing
myths, fairy tales, and folktales?

Japanese
Folktales

Irish
Folktales

The Norse
Myths

Legends
and Tales
of the
American
West

Chinese
Fairy Tales
& Fantasies

Folktales
from
India

The
Victorian
Fairy Tale
Book

Norwegian
Folktales

Russian Fairy Tales

African Folktales

Gods and Heroes of Ancient Greece

A proposal for a redesign of the Pantheon Folktale and Fairy Tale library.

Favorite Folk Tales from Around The World

What are myths in the twenty-first century? Where do these myths reside? What would be their origin? Do these tales mesh, or cohere, in any way, with our world now?

The Complete Grimm's Fairy Tales

Latin American Folktales

American Indian Myths & Legends

A Natural
History of
the Piano

The Instrument,
the Music, the
Musicians—
from Mozart to
Modern Jazz and
Everything in Between

Stuart Isacoff

The silhouette of my Mason & Hamlin grand.

Though I've designed a fair number of 12″ LPs, I rarely have the opportunity to design a square book.

The background for this jacket is the 1936 PRAVDA article "Muddle instead of Music,"
which I dug out of the Slavic Reading Room at the New York Public Library.

Peter Mendelsund is an extraordinary designer not only because he has a splendid graphic sense, an eye for balance and color and rhythm, that put him in the top tier. It is also because he is a reader, a person of deep understanding and keen intellect for whom books are the key to knowledge. Peter has an eye for form which is with him at all times; equally, he responds to each new idea, to a writer's intentions, in a way that is the stuff of dreams. Peter designed the cover of a book I wrote about the architect Le Corbusier. It is genius. He used geometry to divide Corbu's head; we see a bit more than half of the architect's face, while the other half is concealed. That design suggests, in one fell swoop, an idea that is central to the book, and which I spend a lot of time examining in the text: the way that Corbu liked being on stage, presenting himself as dapper and distinguished, trading on his good looks, attending to his appearance fastidiously, but, equally, kept a lot hidden from view. To me the design also suggests the divisions within Corbu's personality. He could be kind and solicitous (to his indigent clients, to the homeless people who would stay in the dormitory he designed for the Salvation Army, to society's disenfranchised), and he could be arrogant and impossible (especially to rich clients who were slow to pay, but, equally, to anyone he considered pretentious). Peter's design for that cover also has the panache of Le Corbusier's architecture, the vibrant colors that were so vital to his work, the textures and materials, the flare, and, for all of that, the simplicity and clarity. You can imagine how happy it made me to see the book clad in a way that so perfectly reflected my intentions.

Most recently, Peter designed two different covers for my book *The Bauhaus Group*: one for the hardcover, one for the paperback. Again, he succeeded in spades. The purpose of the book is to show the Bauhaus not as the dry machine-like institute for design that many people falsely believe it to have been, but as a hotbed of inventiveness, high spirits, and talent, all brought to life by a group of people who were in love with the experience of being human. Here Peter created a dynamic composition that has the verve of the paintings and textiles artists like Kandinsky, Klee, and both Josef and Anni Albers created at the school. He positioned a group photograph of laughing, animated Bauhausler in a way that the assemblage of smiling faces appears to soar just as their spirits do, and he turned a photograph of the school's Dessau headquarters by ninety degrees—just the sort of thing one of the Bauhaus artists might have done in a composition—to convey an image of where so much took place, while evoking it with humor and energy.

These designs, upbeat and thrilling to look at, are works of art, and at the same time they encapsulate the writer's truest goals. I consider that to be a rare achievement, and a total triumph.

nicholas
fox
weber

the
bauhaus
group

six masters
of modernism

IF THERE IS SOMETHING TO DESIRE, / THERE WILL BE SOMETHING TO REGRET. / IF THERE IS SOMETHING TO REGRET, / THERE WILL BE SOMETHING TO RECALL. / IF THERE IS SOMETHING TO RECALL, / THERE WAS NOTHING TO REGRET. / IF THERE WAS NOTHING TO REGRET, / THERE WAS NOTHING TO DESIRE.

Why not a complete poem on the front?

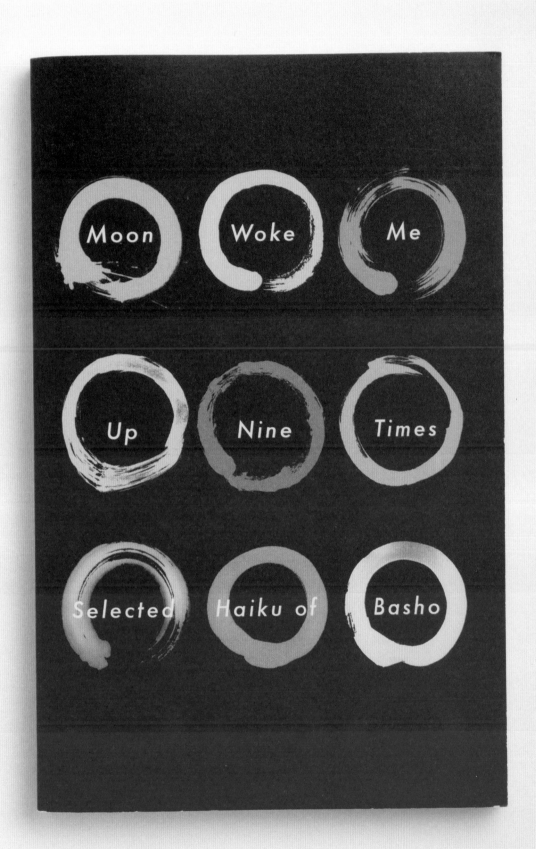

Pointing towards the spiritual affinity between haiku and zazen. Nine mindful circles — nine moons.

(Occasionally, nothing works…)

In the end, this title was designed by someone else. I always feel deeply wounded when I can't manage to get a cover right, but it's good to remember that you can't win them all (or even three-quarters of them.) Someday I hope to successfully design a cover for Geoff Dyer.

Zona
Geoff Dyer

Geoff Dyer

Zona. A Book About A Film About A Journey To A Room

Zona

Geoff
Dyer

ZONA

a book about
a film about
a journey to a
room

geoff
dyer

ZO
NA

A BOOK
ABOUT A FILM BY
ABOUT A GEOFF
JOURNEY DYER
TO A ROOM

Zona

A BOOK ABOUT
FILM ABOUT A JOURNEY
TO A ROOM

X

Geoff Dyer

Zona
Geoff Dyer

about a
film about
a journey
to a room

Geoff
Dyer

Zona

A book
about a
film about
a journey
to a room

Geoff
Dyer

Zona

A book
about a
film about

na
///
ok
out
ilm
out
-
ey
///
om
///
off
///
n-

zona //////
a book about
a film about
a journey to
a room --
geoff dyer

Zona
a book
about
a film
about
a journey
to a room
Geoff Dyer

Zona

Geoff Dyer

Matthew Guerrieri

The first four notes

Beethoven's fifth and the human imagination

"Duh duh duh DUUUUUUUH..."

Hearts of the City

The Selected Writings of

Herbert Muschamp

The book as *building*.

Poems

THE
VILLAGE
UNDER
THE SEA

MARK HADDON

Bestselling Author of

THE CURIOUS INCIDENT
OF THE DOG IN THE NIGHT-TIME

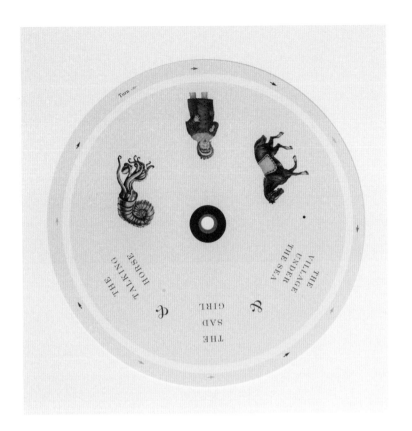

The only jacket or cover I've ever designed with moving parts.

Process

-You're right, that's enough of this, he said to her.
Are you hungry?

-Yes.

After a while he said,

-Driver, get off at Ninety-sixth Street, will you?
Go over to Second Avenue. We'll go to a place I know, he
said to her.

They finally stopped at Elio's. He managed to pay
the cab driver, counting the money out twice. Inside there
was a crowd. The bartender said hello. The tables in front
that were the best were all filled. An editor he knew saw
him and wanted to talk. The owner told them they would have *who he knew very well*
to wait fifteen or twenty minutes for a table. He said
they would eat at the bar. This is Anet Vassilaros, he said.

The bar was equally busy. The bartender -Alberto- he
knew him, spread a large white napkin on the bar in front of
each of them and put down knives and forks and a folded nap-
kin.

-Something to drink? he asked.

-Anet, do you want anything? No, he decided. I don't
think so.

He ordered a glass of red wine, however, and she drank
some of it. Conversations were going on all around them.
The backs of people. He was nothing like her father, she was
thinking, he was in a different world. They sat side by side.
People were edging past. The bartender was taking orders
for drinks from the waiters, making them, and ringing up
checks. He came towards *them* holding two dishes of food. The
owner came while they were eating and apologized for not having
been able to seat them.

-No, this was better, Bowman said. Did I introduce you?

-Yes. Anet.

The editor stopped by them on his way out. Bowman didn't
bother to introduce him.

-You haven't introduced us, the editor said.

-I thought you knew one another, Bowman said.

all that is

resignation

Completion

Lolly — Loll-ness (making due w/ little?)

Everything . whats left?

Romance/Eroticism

Retrospective — memory w/ period mood.

Summing up Nostalgia —
 feeling out. ordains drama

All— amount loss
little?
or lost? last book?

Salter — succession of moods.
 cadence.

heightened sense of the commonplace

 @uotidien.

all type? important book.

Salter → typographical brand

3. Make Broad Decisions

I. Make/ Commission

II. Media

Photography
Illustration
Collage
Pencil
Pen
Paint
Vector
&tc.

III. Typography

Calligraphy
Serif Typography
Sans Serif Typography
&tc.

IV. Palette

V. Category

Abstract
Mimetic
Referential
Sui Generis
All Type
&tc.

VI. Audience

Mass Market
Trade
&tc.

VII. Overall Affect

&tc.

4. Choose Subject Matter

When setting out to design a book jacket for a work of fiction, we designers, whether we are aware of it or not, are picking our subject matter from a limited set of bins. Though the choices we can make as designers are unlimited, the categories that define most of our choices when we pluck these ideas from their native fictions, are, on the face of it, quite easy to list. (I realize that this exercise will seem willfully reductive. But building blocks are supposed to be irreducible, so this crudeness is purposeful. I should also mention that the true basic building blocks of any design are *type* and *image*, and the true irreducible components of any two-dimensional static image are *shape* and *color*.)

In any case, here are some broad categories of subject matter for fiction jackets.

1. "Character"

Put a *person* on the cover. A frequently winning design tactic, though also tricky—as we designers don't want to rob readers of their satisfying acts of imagination. One should always show a portion of a character rather than the whole megillah. Body parts: hands, feet, hair, ears, etc. are—and should be—more common than full frontal facial disclosure. Much of our work is spent hiding, occluding, and interrupting faces.)

2. "Object"

Put a *thing* on the cover—the thing should either exemplify the book as a whole, or else prove critical to the unfolding of the narrative (and hopefully will both). Always compelling, and sometimes serves to establish place, tone, and character as well. Objects are simply saturated with metaphoric potential.

3. "Event"

Put a recreation of, or documentary evidence of an event on the cover. Especially useful if our work of fiction is historical, for which a wealth of extra-fictional reference materials already exist (think of all those Napoleonic War paintings adorning *War and Peace* jackets). The "event" can refer to any occurrence which transpires during the course of a work of fiction (or is alluded to) and which feels particularly resonant (Like, say, the bullfights in *The Sun Also Rises*).

4. "Place"

Put a place (or something indigenous to, or indicative of a place) on the cover. Deploying this category is a very common method for constructing fiction jackets. I cannot tell you how many times I've been told by editors, publishers, and authors that a novel needs a jacket which provides "a sense of place." NB often the "Place" category also provides the "Time" category, as well as the "Theme" category, and obviously all these categories overlap in a myriad of ways...

5. "Time"

Indicate a narrative's time period on the cover. Provided most often as an ancillary benefit of categories 1-4, often of several at once. Though time (and place) may be indicated while employing a relative degree of abstraction as well. Imagine, for instance, a jacket with Wiener Werkstätte pattern adorning it; a keen observer would see this pattern and might guess that the story inside came to pass some time around the early part of the twentieth century and took place in a central-European setting.

6. "Text Sample"

Put an image that corresponds specifically to a line of text on the cover (frequently this line of text will be the book's *title*). One frequently sees jackets designed to represent a textual excerpt. If a designer was given "Gone with The Wind" as a title, I see no reason (except for one of taste) that he couldn't invoke wind, or the "windblown" as his jacket design subject matter (though we designers hate to simply parrot or reiterate book titles on our jackets).

As I just mentioned, titles are frequent sources of inspiration for jacket designers as they often reference the previous categories and are frequently, themselves, windows into the author's main thematic concerns. Which is to say that these two publishing instruments (titling and jacket design) do similar work on behalf of the narrative and in the selling thereof.

As it turns out, fiction titles themselves can also be categorized in the groupings listed above:

Character: *Anna Karenina*; *Tristram Shandy*; *Gilgamesh*; *Lolita*
Object: *The Maltese Falcon*; *The Scarlet Letter*; *The Golden Bowl*; *The Overcoat*
Event: *Sophie's Choice*; *The Tempest*; *The Crying of Lot 49*
Place: *Moon Palace*; *Howard's End*; *The Berlin Stories*; *London Fields*
Time: *1984*; *Parade's End*; *Light in August*; *Spring Awakening*
Text Sample: *The Catcher in the Rye*; *A Handful of Dust*; *The Day of the Locust*; *'Tis a Pity She's a Whore*; *Remembrance of Things Past* (though only in English)

7. "Affect, or Tone"

Put an image that represents the tone or overall emotional disposition of the narration on the cover. Sometimes a jacket amounts to no more than the mood it sets.

8. "The Tell-All"

Put as many explicit plot elements as possible on the cover. "The Tell-All," I realize, is not really a category of material in the sense that the others are—it is, rather, comprised of the other categories, as many as possible, and is thus more of a methodology (an extremely ill-advised methodology).

The "Tell-All" is, most obviously, the raison d'etre of, and pictorial grammar behind, most *genre* fiction jackets (Romance, Crime, etc.) However this method is also deployed in the making of countless literary fiction jackets produced every day. As it happens, this category, this crammed-together grab-bag of plot points I'm calling the "Tell-All" is a tried-and-true favorite of those in

publishing who would believe that the primary job of the jacket is to report as much of the story line to the viewer as possible, and that signaling a book's genre through character and setting is paramount. The "Tell-All" represents the apotheosis of a diegetic form of jacket design (relating to characters, things, etc. inside the primary narrative). There is no editorializing here; there are no veils to penetrate.

Only one part of the author's output is being addressed here—the most mundane part, namely: "what happens" during the course of a given tale.

Which is to say: The "Tell-All" is not merely an admixture of the above categories. Almost all book jackets for works of fiction are admixtures of the above categories. Rather, the "Tell-All" crowds out all other forms of representation, leaving us with nothing more than the particulars of plot.

I detest this kind of jacket.

9. "The Argument"

Put a representation of the book's big thematic idea(s) on the cover. This category stands in opposition to the latter.

When I read I am, involuntarily yet aggressively, seeking *meaning*. Subsequently, my designs tend to involve a modicum of explication and gloss. I find it near impossible to inhibit my textual interpretational tendencies when designing a cover.

Call it training, habit, or base natural instinct.

This category may not seem, on the face of it, a classification of a "raw material," but rather an overarching consideration that colors the way in which the other categories are treated. And, certainly, jackets which address *theme* can be made by using the categories above. However...

10. "The Parallel"

...if a designer finds himself wanting to leave the realm of a story's particulars, theme may be represented using abstraction, all-type solutions, or even through the use of visual subject matter alien to the plot in question. (This situation is akin to when a textual translator is working on a passage that has no analog in a target language. In these cases, *parallels* must be found.) The important thing here is that (the designer's reading of) the author's project be represented somehow.

These are, as you might imagine, very difficult jackets to pull off. These are jackets in which the signifier (the jacket) doesn't in fact resemble the signified (the narrative). It may map to it, but does not *reproduce* it visually. When done well, they are the best sorts of jacket as they leave the author's diaphanous and prismatic worlds unmolested.

As we can see—all of these categories I've just identified seem to collapse neatly into two classes:

1. The narrative facts (Character, Object, Event, Place, Time, Text)
2. The meta-narrative facts (Theme, Affect...)
We might now come to the logical conclusion that jackets are literal or metaphoric; narrative or thematic.

And we would be wrong to do so. It is obvious that these two classes coincide and interact—that jacket imagery can perform some kind of semiotic double duty. (All imagery, in fact, performs "some kind of semiotic double duty," whether intentionally or not.) Good fiction jackets, it seems to me, relay information to the viewer by means of imagery most often constrained to the particulars of a given plot, whilst hopefully, simultaneously, signifying something of the meta-narrative facts as well. In other words: pick a detail native to the story line, and deploy it in such a way as to indicate "bigger things." This technique just outlined takes advantage of a neat little fact about signification, namely that any signifier (a symbol, word, image, etc.) expresses, simultaneously, two channels of meaning: the *denotational* and the *connotational*. These channels correspond to the literal, and the figurative.

The *process* of designing a book jacket, as any practitioner of the discipline can tell you, is far from scientific. No designer thinks to himself: "Today I will put an *object* on the cover of a book." Rather our choices (should) emerge organically from our readings of texts—the texts being the reservoir from which all our ideas flow.

This is to say that the preponderance of our work is: *reading* work.

As I mentioned above, we designers are expected—if we are to be thought of as interpreters rather than regurgitators, or worse: *decorators*—to deploy *both* levels of signification, denotational and connotational, with an eye towards 1. Making a visual rendition of narrative, whilst 2. Carefully selecting the elements according to how well their connotational significance represents or reflects a given author's underlying project. Part one is a snap. It's part two where we designers tend to make a hash of things.

A jacket or cover will most likely have an editorial slant; a POV (and a target audience). But is its message cogent? Clearly communicated? Is it saying one thing or many? Is there, in point of fact, a clear argument being put forward? Many book jackets for fiction titles turn out to be, if examined closely, metaphorically vague, haphazard—and I would posit that it is a trick of the medium that they frequently (only) seem to be specifically meaningful. Whether by virtue of the some thirty-two thousand years of iconographic accumulation; the steady repetition and accretion of empty gestures leading to rhetorical norms; the reading public's widespread fluency with a variety of interpretative methods; the already-rather-dated misapprehension that the text is truly "open," and its attendant delusion that anything, can mean *anything*; or merely the structural open-endedness of the connotational layer just described above, almost any image can appear to be not only meaningful in general, but also germane to any text at hand, while simultaneously failing to be *specifically* meaningful. Most book jackets are accidentally apposite— and, upon scrutiny, they seem to abdicate responsibility for parsing their accompanying texts. Whether through the designer's indifference, or through the designer's use of vague, cryptic, or common symbolism, these book covers fail to present a coherent argument; though, oddly, they may, upon casual glance, seem to do just that. Certainly, the images taken to represent all the other categories I laboriously listed above (Character, Place, Object, etc.) are pregnant with nebulous import, such that designers, plucking from these brimming bins actually seem to have big thematic ideas in mind, when, in fact, on many occasions, they may not. One would think that, if a designer has done his/her work properly, then the most prominent of the meanings that are suggested by their graphical choices *should be* representative of, or resonant with, the author's overall message. But this happens more infrequently than one might suspect. In many instances, a window, or tree, or lock of hair, or a bird that you see on a book cover can mean, or seem to mean, a whole hell of a lot of things— even if that window, tree, lock of hair, or bird means nothing in particular. In their blank assignability, our jacketing ciphers take on meaning that shoppers, readers, viewers assign them after the fact. And thank goodness they do—otherwise, vague thinking would be called out, and book cover design would become a lot more difficult than it actually is.

In order to make a good jacket—in order to perform the strange kind of reverse ekphrasis we are charged with performing—we must find ways to make concrete what is indefinable. A good, deep reading of a text will provide clues to how this can be accomplished in the least offensive manner possible.

5. Sketch

7. Iterate

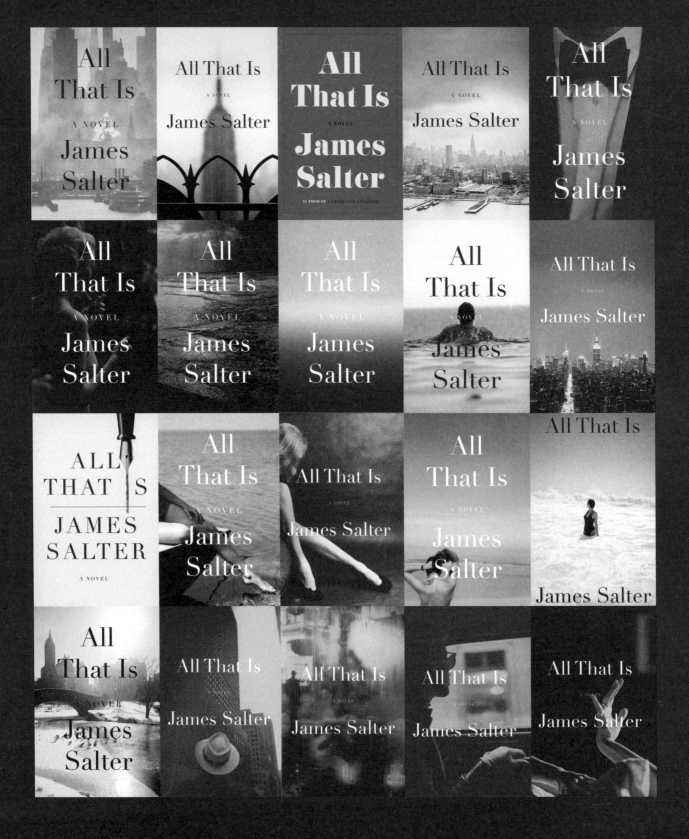

8. Pitch

All That Is

A NOVEL

All That Is

James Salter

James Salter

All That Is

A NOVEL

James Salter

novel

To Peter
with thanks

ames

James Salter

alter

Anatomy of a Cover

When I am designing a cover for a good book, every choice I make feels to me like a diminishment or a perversion…

Every choice of color, every typographical decision, each division of space and every pictorial graft—each step, a step closer to the concretization of the book and thus its impoverishment. It is my job to drag the text, the author's work, perfect in its disembodiment, into awful specificity. At which point, no matter how well I've done my work—no matter how pretty the cover is—I feel a sense of loss.

I always knew that I'd be unsatisfied with whatever cover I might design for Julio Cortázar's jazzy, melancholic, metafictional masterpiece *Hopscotch* (which just turned 50)—it would always be found wanting in some way or other. The texts you care about the most are the most difficult to design covers for— and I've loved *Hopscotch* since I first read it at sixteen. I spent weeks working up various *Hopscotch* covers. I could have spent years. I still, occasionally, feel the urge to pick up again where I left off, and continue designing *Hopscotch*.

There are certain books, this being one, for which one could, theoretically, just envisage cover after cover, all incorporeal, safe from the press rollers, lovely abstractions, covers which, asymptotically, inch ever closer to the text itself, to the book's quiddity, until the cover becomes the text, and they are indistinguishable, cover and text, text and cover, like a man staring at an axolotl in the Jardin des Plantes for so long that he finds himself, eventually, sporting webbed feet and living on the wrong side of the glass.

But one does find (out in the world), that one has to, at some point, cease

envisioning—which is to say that things must sometimes be *made*. At least, when the book date comes around, one must produce a cover. Perhaps not *the* cover. But *a* cover.

I don't think I will stop making *Hopscotch* covers, though. As Cortázar writes: "I realized that searching was my symbol, the emblem of those who go out at night with nothing in mind, the motives of a destroyer of compasses." The emblem of this book may also be "searching," and this book, this novel, may be a destroyer of covers. (I should have tried a ruined compass for this cover.) But please be at peace with the ones I've made, for now at least. And maybe we lovers of *Hopscotch* will all dust off our maté gourds and gather around on some violet evening yet to come, and talk about what might have been the cover for *Hopscotch*, what might someday be a cover for *Hopscotch*, and we will imagine a plastic world, full of transient covers, "full of wondrous chance, an elastic sky, a sun that suddenly is missing or remains fixed or changes its shape." Or perhaps we will lay out all the covers, all possible covers, down upon the sidewalk, and throw a pebble, and see which one, of the infinitudes, it lands on.

What follows is a litany of ideas—the final cover, followed by comps for *Hopscotch* and *Blow Up*—these were the ideas the pebble did not land on.

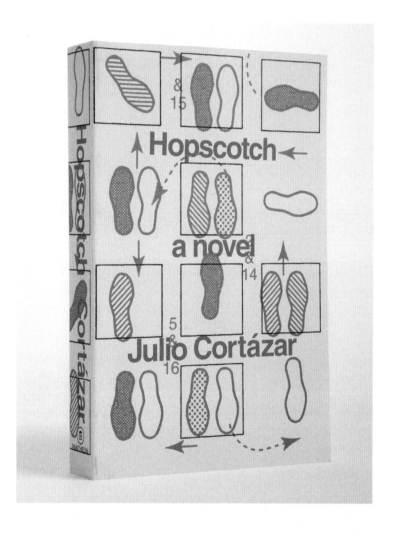

The final, which wraps the Pantheon edition
of HOPSCOTCH as it appears in stores. It
features the steps of a tango, superimposed
on a "rayuela," a hopscotch field. Using a
game of hopscotch as a visual device always
felt like the most apt (and most obvious)
solution for the cover. (HOPSCOTCH, the
novel, may be read like any book: front to
back. It also may be read by "hopscotching"
through the chapters according to a set of
instructions given by the author.)

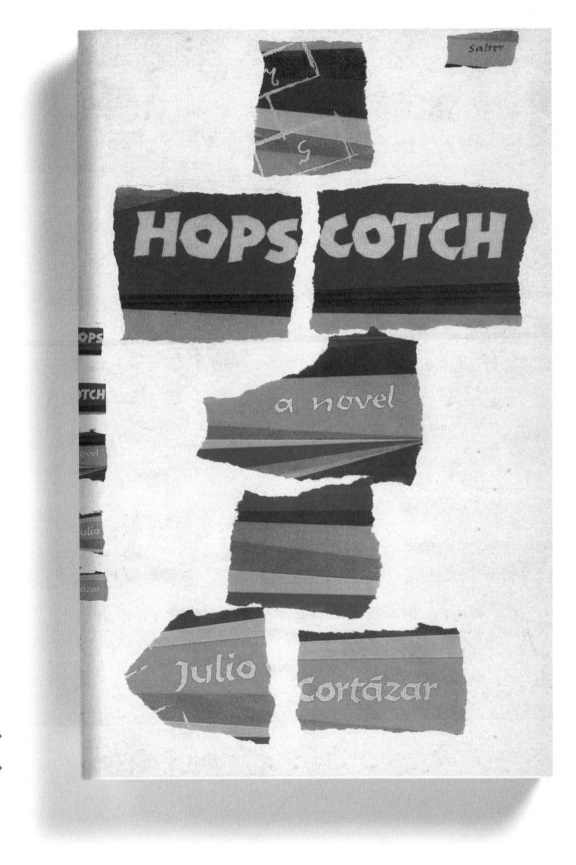

A cover which is an amalgam of pre-existing material (Like Berthe Trépat's "Delibes-Saint-Saens Synthesis" from Cortázar's novel.) The torn sections of this collage were taken from George Salter's first U.S. edition design.

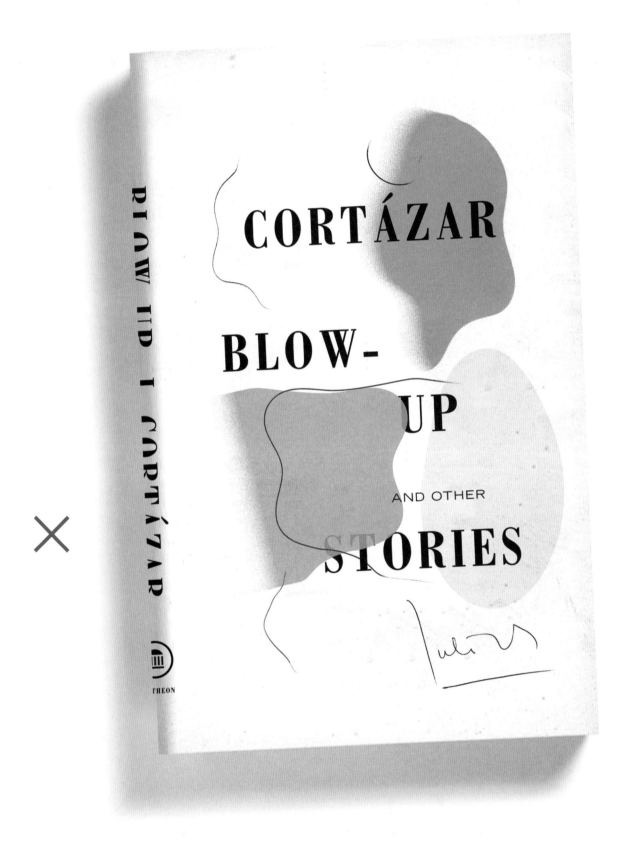

Sometimes, I'll try a treatment which is inspired by a particular artist whose style speaks to the narrative in question.

In this case, the jazziness of Miró, seemed appropriate to emulate.

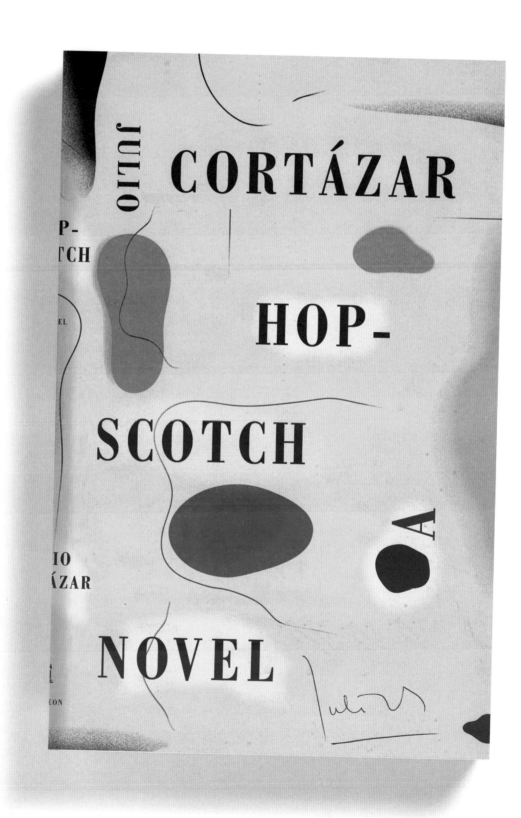

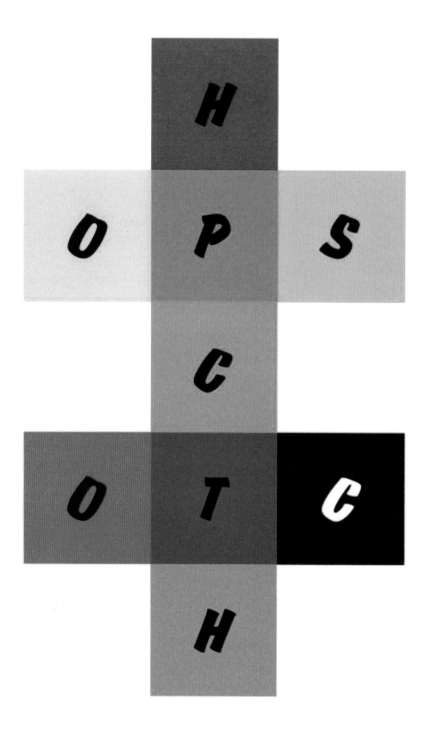

This cover is, in many ways, an even more adventurous visual treatment than the last. And it was a favorite of mine. But ultimately, I decided that the committees overseeing these sorts of things (editorial/sales/marketing) would never approve this comp. "THE TITLE IS HARD TO READ," they would complain. ("The book is hard to read," I would silently retort. "That's one of its principal merits.")

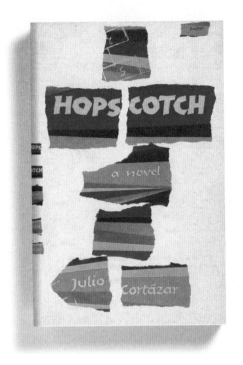

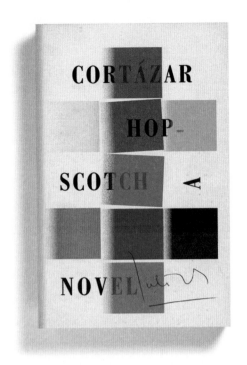

Every broad idea for a cover calls up a coterie of variations. I always try out each general concept in a variety of media (collage, illustration, photography) and using plethora of typographic directions. All of these details help to establish the affect of the jacket.

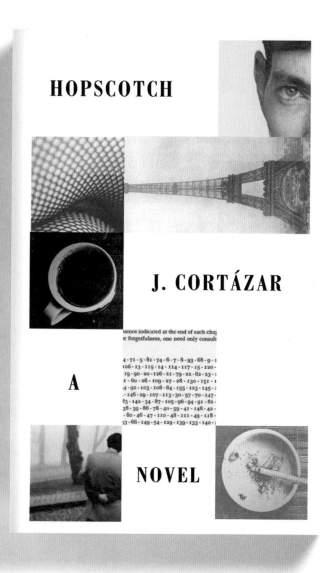

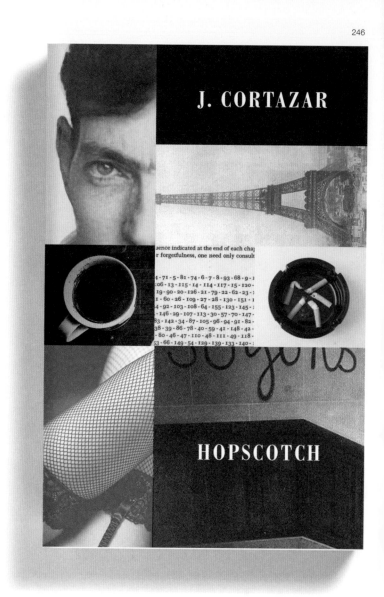

Is every novel a cryptic portrait of its creator?

I briefly considered using one of Brassaï's photos of Parisian graffiti, but then looked on my shelves at home and saw there, FOUR of Jacques Prévert's Le Livre de Poche editions using the same photos on their covers, to better effect. Someone always gets there first...

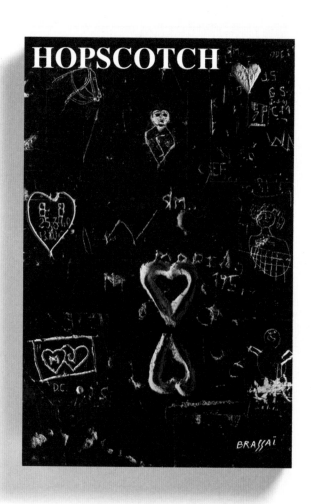

AT RIGHT: HOPSCOTCH is a brilliant narrative experiment, but it is also, ultimately, a love story. So here, I tried the most clichéd thing imaginable: a heart and an arrow. I then set about subverting the cliché in a manner that reflects the author's topsy-turvy style of storytelling. (The stylistic inspiration here is, appropriately, Latin American book covers of the sixties.)

HOPSCOTCH
A NOVEL
JULIO
CORTÁZAR

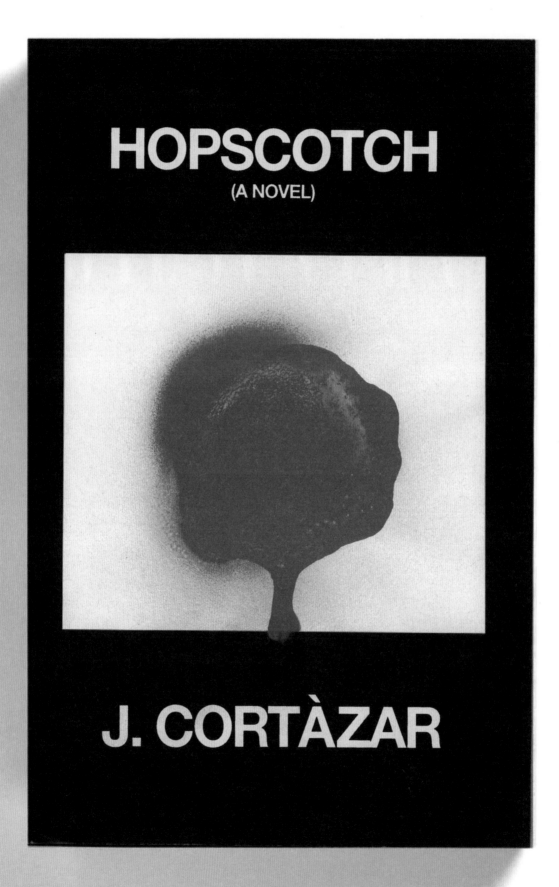

AT LEFT: I briefly imagined this
novel with an empty white box on
its front. The idea was to
encourage the reader to make his
or her own, custom designed
HOPSCOTCH cover. Draw a picture;
sign your name; spray-paint it (as
I did here); leave it blank...

Then I realized that I'm drawing
a salary because making covers is
my job. It felt like
an unnecessary abdication.

Still, this one was pretty.

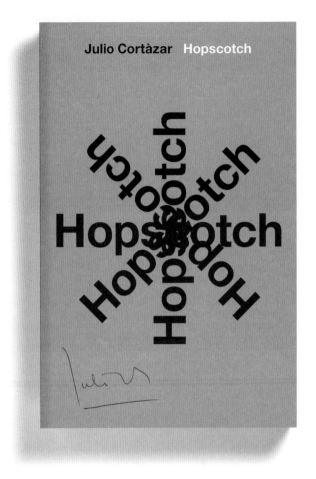

How hard must the viewer work to decipher the title?

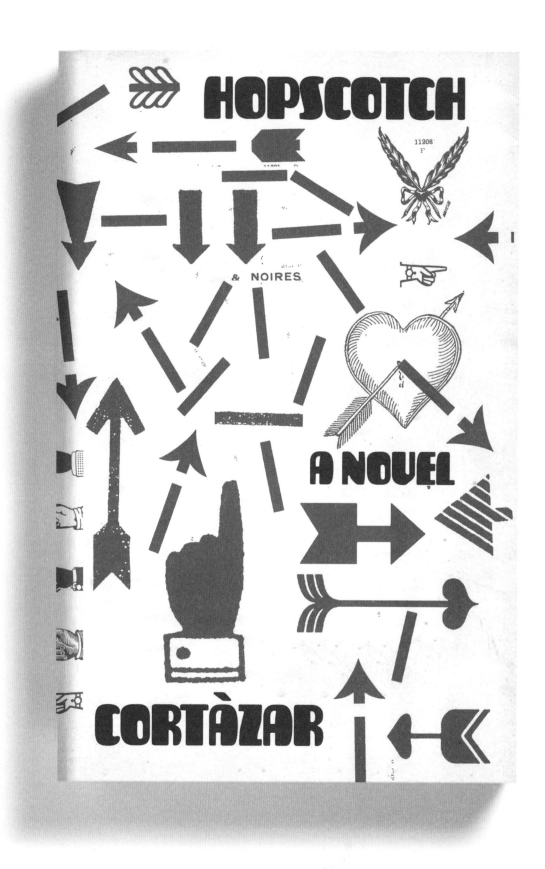

I'm always searching for the most *unfashionable* typefaces I can find.
This one did the trick nicely.

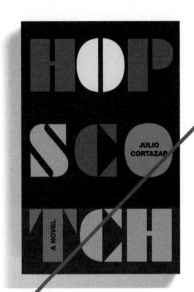

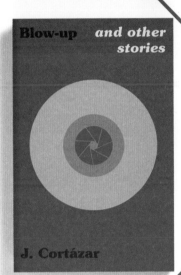

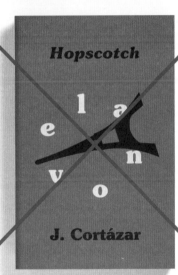

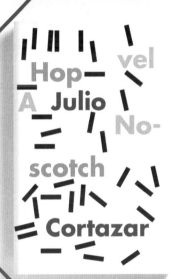

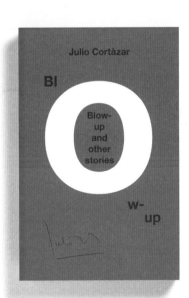

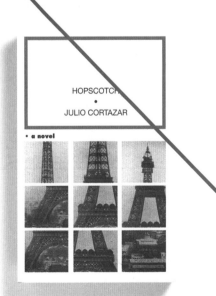

(I still hadn't shown anything for approval at this point.)

Julio Cortàzar Blow-up & Other Stories

These two could have worked. I wouldn't have regretted it if they had ended up final covers. But I still had time to play and think. So I kept going.

SCOTCHHHOP
COTSHOPHC
HOPSCOTCH
POHSCTOHC
SCOHOPTCH
PSOHTOCHC
THOSHPCCO
J.CORTÁZAR
OOPSTHHCC

I made close to fifty more covers after designing these two. As I mentioned,
the end of the process was, as it always is: arbitrary.

Stumbling on HAPPINESS

DANIEL GILBERT

KNOPF

Life Delüxe Lapidus

Pantheon

LEE VANCE RESTITUTION

KNOPF

PICTURES AT AN EXHIBITION
SARA HOUGHTELING

Knopf

Q & A

Q & A with Josh Cook from Porter Square Books, Cambridge, MA.

258

How would you describe your job as a cover designer?

I am paid to read great books and interpret them. I have the greatest job in the world.

Do you feel any particular responsibilities to the book, author, and/or publishers?

My job as book designer and art director is predicated on the idea that I will help sell a book, and to the extent that I do that, successfully position a book in the marketplace by making the appropriate jacket for it, I am fulfilling my responsibilities to the publisher.

In terms of my responsibility to the author and the book…representing the text is not (at least not patently) something I'm paid to do, but I see this act as a moral imperative. Characterizing, explicating, interpreting a text visually is the most interesting and gratifying aspect of what I do. When I fail at this task of signifying what a book is (or I am urged or directed in some way to betray what I see as a book's essential nature) there's a palpable sense of loss and guilt. It feels important to me that a book's cover should not be dissonant with, or oblivious to, the text within. A book cover should be a book's true face; which is to say, optimally, a jacket or cover will be a kind of visual translation of the book in question. So—to the extent that I successfully describe or epitomize a book—its plot, its themes, its affect…I am fulfilling my responsibilities to the book and to its author.

What makes for a successful cover design?

A good cover should sell a book, and adequately represent what it is. It should work to entice a browser, and serve as a lasting emblem of the experience of having read a given text. There's no formula for how to accomplish this. Which is to say that every good book cover is as unique as the text it is wrapping. But there are certain general rules of thumb I think a designer could cleave to: a good book cover

should be pretty, or visually stimulating in some way—and it should look different from every other book cover around it. I count originality highest of all cover-design virtues.

What makes for an unsuccessful cover design?

I can't stand covers which imitate other covers, or which slavishly look like whatever their designated genre is supposed to look like. I really dislike any cover that is a cliché, or that consists of clichés. There are visual clichés, tropes for every genre we publish—crime, chick lit, horror, history, science…even (or even especially) literary fiction…

A new book needs first and foremost to catch a browser's eye, and, in order to do so, the cover has to stand out in some way. (Things stand out, tautologically, by looking distinctive, different from what's amassed around them). I can't stress this point enough. There are so many books published every year, and so many of their covers look alike. Don't they?

This is, of course, a product of a kind of insularity in the publishing business, the ways in which publishing is an echo chamber. But it's also a product of a marketing culture that can exist anywhere, which can think of no better methodology than imitation. There is a fundamental fear that underlies many of the decisions made around book jackets; in this market, publishers want covers they think are safe bets—i.e. covers that are similar to other covers that have worked in the past. Unfortunately, by dictating that designers produce genre-ready, hackneyed, copycat covers, publishers are insuring just the opposite of their intent: they are insuring that a book will get lost amid the clones (or at the very least they are insuring that the jacket won't be helping to make the sale).

I prefer ugly covers to clone covers. At least ugly covers demand a certain amount of attention.

What is your design process?

I get the manuscript from the editor or author—and I read it. (Sometimes twice.)

That's the lion's share of the work. Something tends to happen to me during the reading process—a visual idea will occur; something that can visually epitomize the entire text…

…then I sketch the idea quickly on paper…

…and then comes the process of actualizing that sketch. When I'm at the office I play with typography and color, and shape, maybe I experiment with photography or I'll draw something, or collage something…sometimes it's all done on the computer, sometimes all on paper…the construction stage of this process is very unscripted. I'll just continue to make things until the idea is realized as well as it can be.

Besides other book covers, what influences your design?

Anything is a potential catalyst for a cover idea; the stimulus can come from anywhere. But one has to be on the lookout. I don't think inspiration is something you passively receive. I'm always looking—everywhere. And there are certain kinds of visual acts which I'm always hoping to stumble upon. Unusual juxtapositions, surprising color combinations, new modes of visual expression…I am always interested by anything graphical that strikes me as (this is difficult to put into words) excitingly wrong. There is a cool-factor to certain images that lie just on this side of disagreeable…pictorial effects that make me think, "This will bother a lot of unimaginative people." Whenever I see something like that, a piece of art or graphic design that has that special kind of wrongness about it, I think, "I need to do something like this myself." Attendant to this is always the feeling of, "In the future, this will be done a lot." In other words, today's ugly is tomorrow's beautiful. The cover I made for Simone de Beauvoir's *The Woman Destroyed* came out of this impulse. It's ugly, but hopefully it's interesting,

and arresting. Hopefully!

Do you draw from art, advertising, pop culture? Is there anything you try to block out when working on a cover?

I definitely try to stay attuned to the fine arts world, though I don't have a lot of time to see exhibitions. I'm not as plugged into the popular culture as I could be. (The positive side of this is that I can't be accused of doing anything trendy.) The only things I consciously block out are ideas or images I'd deem stale or commonplace.

Is there a difference between designing a cover for a new book and re-designing a cover for a classic, like the covers you've done for Kafka, Joyce, and Foucault?

Those were definitely some of the most rewarding projects I've worked on recently. Both projects were really self-generated, and neither, believe it or not, were subjected to any editorial or marketing interference whatsoever!

The most obvious difference is that, in the first case you mentioned, when I'm working on a new book, there is a living author who can influence my thinking, either through direct or indirect intervention; who can improve, or impair my work.

(By the way, I've noticed that dead authors get the best book jackets. I'll let you draw your own conclusions as to why this is…)

The benefit of working on a newly written text is that one comes to a new work tabula rasa, without preconception or bias—there's no critical history to contend with. With a classic, there's all this cultural, critical, literary baggage that has to be accommodated. I've been working on repackaging Marguerite Duras' *The Lover,* and it is hard to do so without referencing all this critical thinking which, frankly, I'm not sure is relevant to my task—like Gramsci and Spivak and Said and the subaltern and feminist theory, postcolonial theory…it's exhausting. Just to read the

story and present it, without drowning under all these glosses is…difficult. But in some cases it is also hugely rewarding. For each of these backlist projects I do a huge amount of rereading— especially in the case of Joyce—of the primary and secondary texts, biographies; I visit rare book collections and libraries in order to view first editions and other extant editions…my series covers come out of that immersion.

Could you describe how you created, or the thinking behind, a couple of my favorite covers: *The Enchanted Wanderer* and *The Flame Alphabet*?

It's funny, these are, of all my recent jackets, the most purely decorative— they describe almost nothing about the particulars of the book (plot, character…), but I'd say they both seek to convey something about the prose, the language itself, and the feeling of reading these (idiosyncratic) writers. Leskov's prose style is so strange, digressive, arrhythmic, odd at the sentence level, but even at the word level (there are these crazy portmanteau words in his stories, almost Joycean or Lewis Carroll-esque inventions; I frankly have no idea how Pevear and Volokhonsky translated some of these stories.) One wants to say that Leskov's stories seem very modern, and they are modern in many ways; but there is a kind of engaging primitivism about them as well—he seems to be imitating a Russian folk demotic, but the effect is very, very new.

Also, Leskov has no compunction about introducing characters and then forgetting about them; creating a narrative thread and then unceremoniously dropping it… None of the rules of classic narrative apply here. The stories are these shaggy dog constructions—I guess that's where the jacket finds its starting point. The jacket, the arrow on the jacket, describes the strange, meandering form the stories take.

Ben's work is also refreshingly, startlingly unconventional. In the case of *The Flame Alphabet,* I was struck with a single metaphor in the book (birds)

and was taken with the idea of making the book feathered. So I made a bunch of feathers for a jacket. But it didn't look right. So I turned the jacket upside down…flames! A similar thing happened with the jacket for Ben's forthcoming book of stories, *Leaving the Sea.* I started making fish scales for the cover, and ended up with an ocean. For all one's planning, sometimes these things just happen serendipitously.

Too often self-published books or books from publishers without much of a design budget are really hindered by their covers. What advice would you give to self-published authors, small presses, or any other amateurs who find themselves in need of a book cover? Are there some principles that will help them create good covers no matter what resources they have? Or, are book covers just one of those things you really should leave to the professionals?

The best principle to keep in mind is: keep it simple. Most self-published book covers fail because they are trying too hard. Even design professionals fall into the trap of trying to shoe-horn too much design into one composition. I often tell students, "Your problem isn't that you have poor ideas, it's that you've got five ideas competing on the same page at the same time." Simplify. If in doubt, stick with typography. Make sure the typography is legible. Use your handwriting if your handwriting is decent. If not, use a font. Any tried-and-true standard face will do (Bodoni, Baskerville, Garamond, Helvetica, Trade Gothic…) Pick a pretty color for your background. Voilà. When you start to incorporate illustration, photography, etc. the amateurishness of the work begins to show. But there's no need for any of that stuff. Many of the best book covers are as simple as could be.

There's really no obvious reason why anyone can't make a decent book cover—the skills required are easy to master. The tricky bits all have to do with taste and reading ability. Those parts may be a little bit harder to learn though.

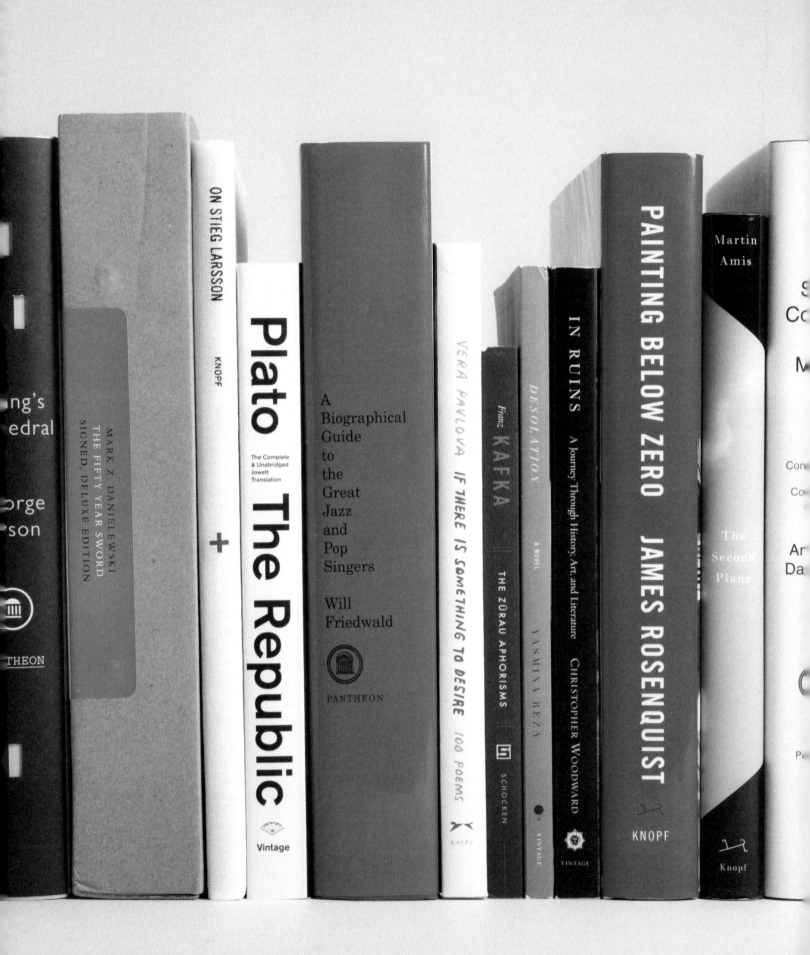

Next

Late Style

Is there such a thing as *late style* in design? Late style (as you'd imagine) refers to the work composed by an artist towards the end of his life or career.

Late style can occur, for an artist, almost as a symptom of advanced age. "Late style" emerges with the artist's awareness that death is, if not necessarily approaching, then inevitable. This intimation of mortality (coupled with the achievement of technical mastery) leads to late style. Examples of late style would include Shakespeare's *The Winter's Tale*, or *Tempest*; Tolstoy's *Hadji Murad*; Matisse's cut paper; Henry James's *The Wings of the Dove*; Wittgenstein's *Philosophical Investigations*; Beethoven's opus 132…

(Late Beethoven, the Beethoven of the last quartets—for Adorno, Said, and others—is the very paragon of "late style.")

Late style is generally thought to describe, not only an artist's *autumnal* works, but also his best works.

Therefore late style is always assigned to works ex post facto.

Late style is not necessarily the result of a *lengthy* career:

Haydn, for example, throughout his long working life, never truly developed a late style. Keats's late style arrived during the six years before his death at twenty-five. Keats attained in poetry what he never attained in life: a "season of mists and mellow fruitfulness."

Late style is made up of strange, almost warring bedfellows:

Wisdom and rebellion; nostalgic longing and philosophical detachment; existential sobriety and religious reckoning; stubborn, hard-won intransigence and nothing-to-lose flexibility…

Late style generally entails liberation from the strictures of established form.

Late style presumably occurs in all media.

Where is the late style in graphic design? Amongst designers, whose late style

do we ponder and admire?

There are many *older* designers in the public eye. There are many *experienced* designers garnering their share of attention. But it seems that, as designers age, they tend to evolve into statesmen rather than master designers; much as ball players become coaches and play-by-play announcers. (Of course, with athletes, physical limitations mark a necessary end to their careers. Which is to say: Why do designers go to pasture so early? Eye-strain?) There is a common assumption that older designers give talks, teach, and write books whilst younger designers create groundbreaking work. We have "Young Guns" awards, and, at the other end of the spectrum, medals for lifetime achievement. Of the elder statesmen and women who are still active designers—the highest accolade one gives is to remark on the enduring *freshness* of their approach. This kind of praise indicates to me that design prizes vigor and novelty over substance and gravitas.

Of a design hero of mine, my senior (and better), a mentor of sorts, I always say, "She designs like a twenty year old." This is meant as, and is, a high compliment. (In case young designers are unaware: maintaining a fresh, ever-renewing eye, over time, is very, very difficult. Few accomplish this feat. Taste is neither innate nor permanent, rather, taste requires training and upkeep.)

I notice that we occasionally admire *the very fact* of an older, still-functioning designer, but expend very little thought on the nature and quality of the work produced. When the work is praised as representing a summation of a life's work, I've observed that this work tends to be categorized in the "fine art" bin, rather than in the "great design" bin; as the "serious" work tends to be, say, the paintings or collages that the designer had always maintained as a sideline. Have you noticed this?

In other words: Is it that the medium of design isn't robust enough to support late style?

Of a recent article about an elder design statesman, I noticed how the article's writer edged away from discussing this designer's work, and that the gist of the piece concerned the subject's writing, his philosophy, his mutating relation-ship with clients. This article had all the trappings of a late style paean, but it stopped short of describing what, from a graphical perspective, would have been the interesting bit, the meat and potatoes: *the design work.* Can you imag-ine an article on Monet in his later years that wasn't deeply engaged with his water lilies? A quote from this particular article's subject: "There are three

responses to a piece of design—yes, no, and WOW! Wow is the one to aim for."
If these are the only three responses to a piece of design—is it any wonder
design has no late style?

Late style might provoke, if not "wow": "Hmmn…" or, "Really?" or, "Aaaaah."

Maybe even, "What the *hell*…?!"

If design itself is predicated on youth (certainly the preponderance of things
sold, are sold to the young—or so it would seem, if our mass media is to
be believed) then late style isn't feasible.

If design is *not* predicated on youth; perhaps it demands *timeliness*.

Familiarity with the zeitgeist is integral to design.

Conversely, *repudiation* of the zeitgeist is integral to late style.

Is the very paucity of older, working, in-house designers itself the necessary
result of design's deal with the devil—its dependency on the marketplace with
all of its attendant fashions?

Designers, if they are good at their jobs (sometimes even when they aren't)
eventually become art directors or creative directors—jobs that rely less
on one's skill as a designer. I myself am one of these art directors (though God
knows I try to keep designing as much as possible), so I tell you from experi-
ence that nothing atrophies one's taste and skills so much as art direction—
with its necessary reliance on *other hands.*

A general lack of older designers in in-house design departments could thusly
be blamed on upward mobility: fewer older, working designers leads to less
late style around to notice, and praise.

Though I believe there is more to it.

I fear that design *is for the young*.

Of a well-known established designer: As he ages he becomes more and more
tone-deaf to typography. And who could blame him? He's probably set tens of
thousands of words of copy in his career. His emphasis now is on The Big Idea,
not the paltry minutiae. (Speaking of deafness: Beethoven was famously

irascible about the prissy details of his métier. Of course the sheer glory of his genius subsumed his idiosyncrasies; his bad taste. Beethoven's genius made of his spastic ugliness: late style.) But, *design cannot support such a disregard for detail*. In the case of design: the typography, the detail, IS the design. Without, say, pretty type, you have ugly, ineffectual design.

Worse, of course, than an *ugly newness,* is a *cookie-cutter sameness*. "Boilerplate" is also a symptom of aging.

(Do we *graduate* from design?)

What will become of me as I age? I am no spring chicken myself—having come to the whole mishegoss rather late. I am forty-five now.

I am "midway through my life's journey." (Did Dante enjoy a late style? In *The Divine Comedy*, Dante's ((literally)) middle-aged avatar is guided by an older, wiser Virgil. In the field of graphic design, wouldn't we prefer Beatrice for a guide? To remind us of those trends which we *aging* designers no longer track? Beatrice would know what the cool kids were up to.)

What will become of me as a designer as I age?

I don't know—and maybe this is why I'm so intent on solving the mystery of:

Whither all the *mature* design?

Matthew Arnold believed growing old meant:

"Los(ing) the glory of the form, the lustre of the eye."

I can't help thinking that if we apply this verse to the commonly held design virtues of "form" and "eye," then I'm in for a sad professional dotage.

In which case I'll return to music? Or maybe I'll find myself, as I suggested in the foreword to this book, performing some third task altogether. Perhaps this book, and the ones that may follow it are that third thing? Maybe I'll find a way to remain a designer—who knows? But if I do, I'll need a late style.

WHAT WE SEE
WHEN WE READ

PETER
MENDELSUND

THIS PAGE, AND AT LEFT: My first two books.

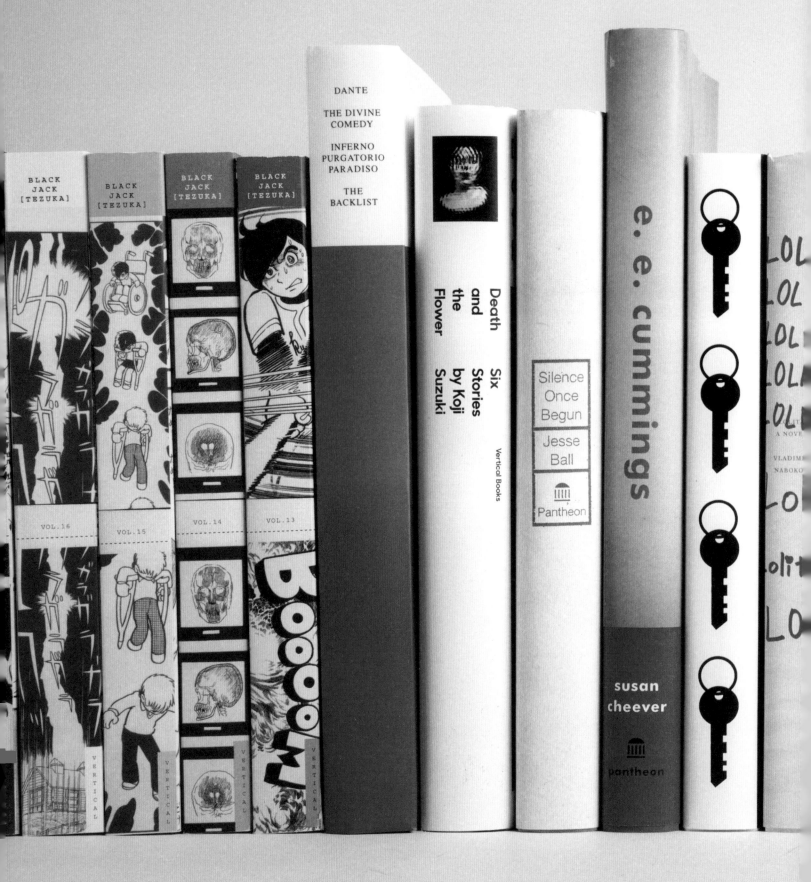

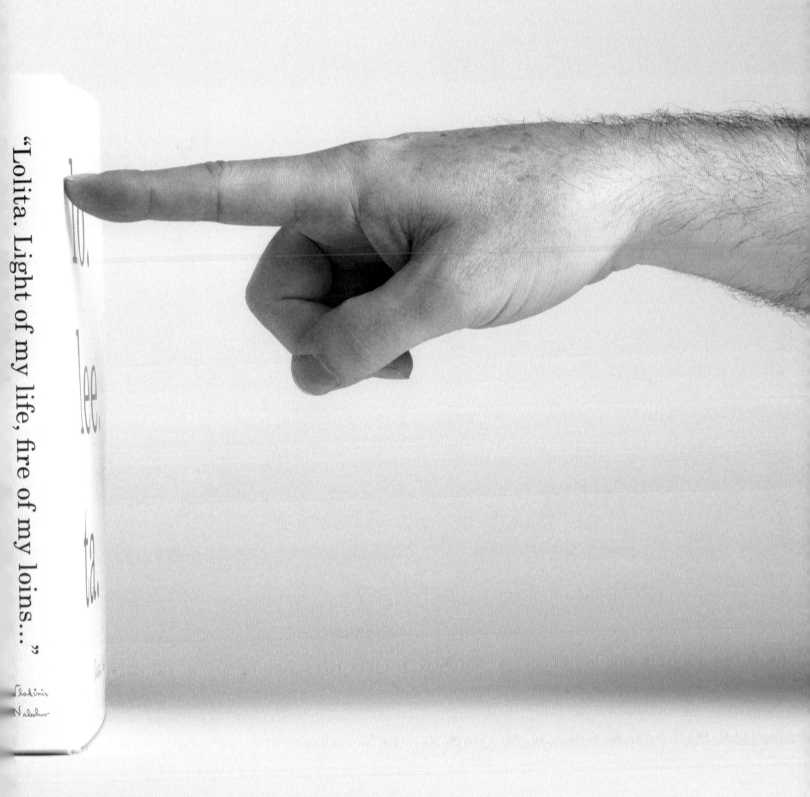

"Lolita. Light of my life, fire of my loins..."

Vladimir
Nabokov

Acknowledgements

Thank you:

Carol Carson and Sonny Mehta.
Whatever there is to owe here:
I owe to you both.

Pablo Delcan, George Baier IV: for the
design work and the photographs;
the enthusiasm; the diligence. You made
this book (quite literally).

My editor Wes Del Val: whose idea this
was, and who guided these proceedings
with energy and with intelligence.

Will Luckman, Craig Cohen, Declan
Taintor and the powerHouse team.

Randy Reed: production genius.

Finally, my dad, Ben, who was a visual
artist, and who died long ago, back when
I was a pianist, and who never had even
an inkling that I might have a visual bone
in my body. I can't help but wonder what
he'd make of all of this (I hope he'd
smile).

ver